CHARLES EVANS' POCKET BOOK

FOR

WATERCOLOUR ARTISTS

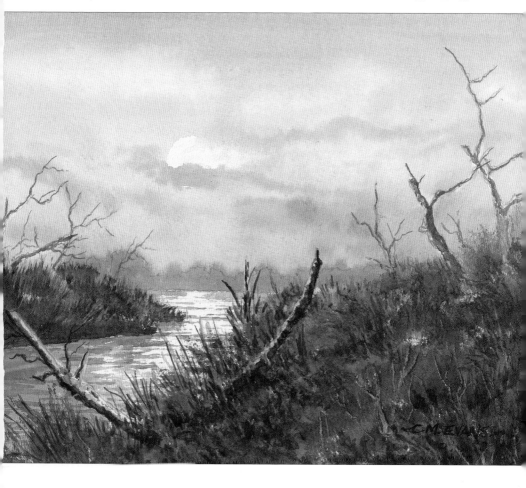

First published in 2011 as *Charlie's Top Tips for Watercolour Artists*

This edition published in 2018

Search Press Limited
Wellwood, North Farm Road,
Tunbridge Wells, Kent TN2 3DR

Reprinted 2020, 2021, 2022, 2023, 2024

ISBN: 978-1-78221-637-7

Suppliers
If you have any difficulty obtaining any of the materials and equipment
mentioned in this book, then please visit the Search Press website for
details of suppliers: www.searchpress.com

Acknowledgements
I would like to thank Winsor & Newton for their continued support and
supply of superb art materials. Also a big thank you to Katie Sparkes
for doing such a good job of translating all my garbled scribbling!

Publishers' note
All the step-by-step photographs in this book
feature the author, Charles Evans, demonstrating
how to paint with watercolours. No models have
been used.

Page 1
Moonlit Lake

Page 3
St Mary's Lighthouse

Page 5
Wensleydale Farmhouse

CHARLES EVANS'
POCKET BOOK FOR WATERCOLOUR ARTISTS

CHARLES EVANS

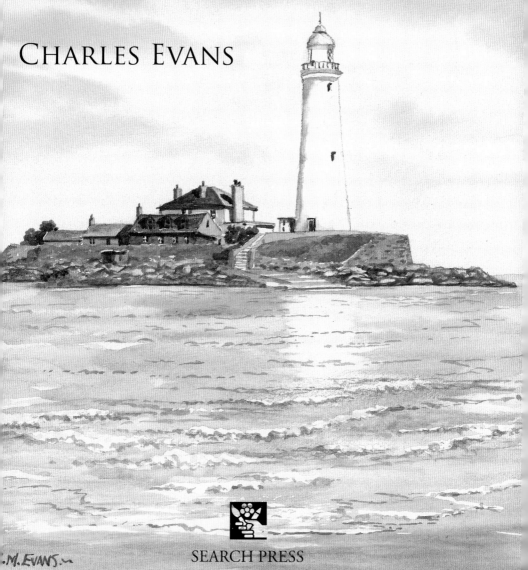

SEARCH PRESS

This book is dedicated to Gail, without whose excellent organizational capabilities I wouldn't have had time to do this book.

CONTENTS

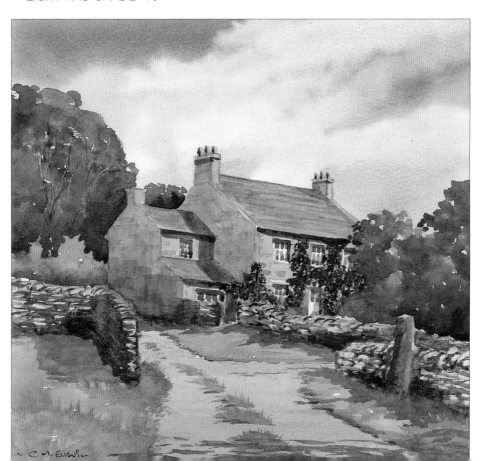

ABOUT THE AUTHOR

Charles Evans is one of Britain's leading painters. His exuberant and likeable personality is reflected in his paintings, which have a lightness and simplicity that many artists aspire to. Charles lives near Morpeth in Northumberland where he runs his own art classes from his studio, which is also his gallery. He travels extensively throughout the British Isles and Europe, running and holding painting holidays, as well as visiting art societies. He also travels extensively throughout both Northern and Southern Ireland. His most recent TV series, *A Brush with Britain,* had filming locations all over Britain rather than just his beloved North East, which provided him with the opportunity to capture and show the audience many different beautiful places in England and Scotland. Charles is now the main demonstrator for Daler-Rowney.

The scene below is the view from Charlie's cottage in Northumberland, which he painted using the techniques explained in this book.

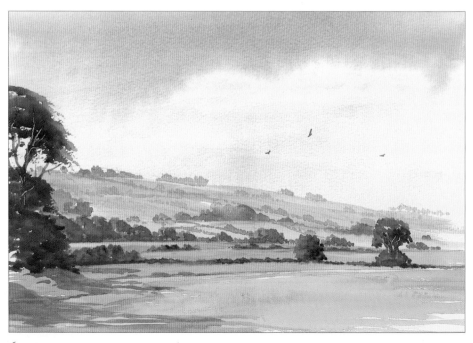

INTRODUCTION

The aim of this book is to pass on some of the many tips and techniques that I have amassed throughout many years of painting. Some of the effects and techniques within a watercolour painting can be quite difficult to achieve, but if there is an easy way of doing something that I can pass on to you, then it is probably in this book.

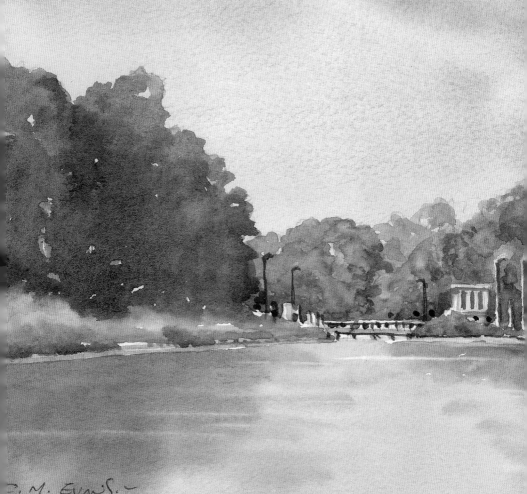

J. M. Evans.

These are not clever little tricks executed on a plain white piece of paper; these are the methods that I actually use in my paintings. Some of them were taught to me by my peers many many years ago. Others are the result of simply playing and experimenting, while some have been happy accidents, learnt almost by chance during my many years as a landscape painter. Hopefully, with the aid of this book, your paintings too will improve.

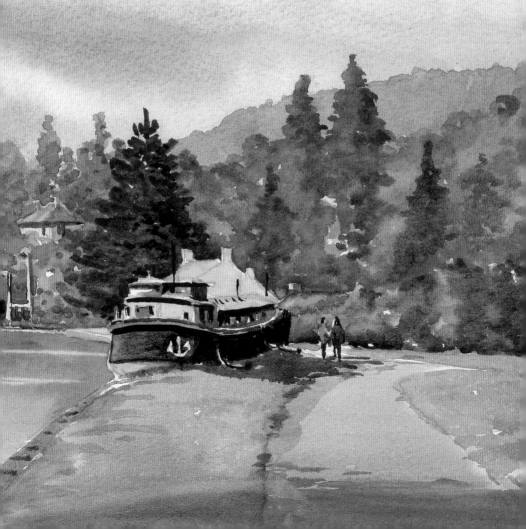

MATERIALS

You don't need a lot of expensive materials to create successful watercolour paintings. This section will help you choose which ones to buy.

Paper

There are many different types of watercolour paper available. There's no need to go for the most expensive, but it is important to choose a good-quality one.

Which weight of paper?

There are some very expensive papers on the market, some of which are extremely heavy, such as 600gsm (300lb). These papers can act a little like blotting paper, which is why I don't use them. The paper I prefer to use is Winsor & Newton artists' watercolour paper, which weighs only 300gsm (140lb). This weight of paper is favoured by the majority of landscape artists.

Rough or smooth?

I prefer to use paper that has a good rough surface, but is not so rough that you can't achieve a straight line when drawing with your pencil. In the past I have also used a NOT paper, which lies somewhere between a rough and a smooth (hot-pressed) paper. Some sort of surface texture is necessary in order to achieve some of the effects demonstrated later in the book.

Stretched or unstretched?

I never pre-stretch my paper. The type I use is sized on both sides, which means that you can paint on either side and, even though I put a lot of water on to some of my big washes, it still doesn't need pre-stretching or any kind of preparation at all – I just attach it to my board and paint.

Easel and board

Angle your paper as you work

I always paint at an easel in an upright position. A lot of people have difficulty painting at an angle, but even a slight angle is good enough – try simply placing a couple of books under your board.

If you paint with your paper completely flat, the water has nowhere to go, and instead will sit in puddles on your painting.

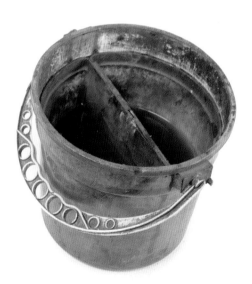

Water bucket

Use plenty of water when you paint

I use a plastic bucket with two halves, one for clean and one for dirty water. This avoids continually having to run backwards and forwards to the sink re-filling numerous jars with clean water. I simply fill the two halves of my single big bucket and this lasts me for an entire painting. It hangs on my easel and is always there, close at hand, with my brushes in it.

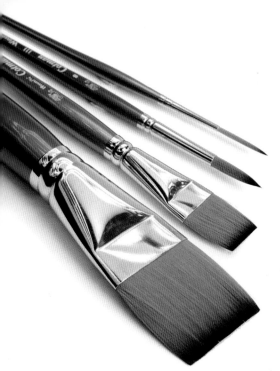

Paintbrushes

How many brushes do I need?

You only need four classic brushes. I use Winsor & Newton Cotman brushes, which are good, sturdy brushes that will stand a lot of abuse. I use a 4cm (1 ½in) flat wash brush; a 2cm (¾in) flat wash brush; a no. 8 round and a no. 3 rigger. These shapes and sizes of brush have been used by artists for centuries, though the way they are made is very new. The hairs are totally synthetic, but with a rounded filament that is tapered to mimic natural hair. These brushes will hold a lot of water and retain their shape, and I find that they don't cast any hairs.

Look after your brushes, and they will last a very long time

When I am painting, I keep all four of my brushes standing in my water bucket ready for use. The flat brushes can be stored safely head downwards because nothing is really going to damage them. The two round brushes – the no. 8 round and no. 3 rigger – are better stored with their heads sticking out, because once the tip or the point folds over it is very difficult to get them straight again.

When I finish painting at the end of the day, I simply wash out my brushes in cold, clean water and then squeeze them out between my fingers. This I will do a couple of times before putting them away in my storage box.

Should I buy synthetic or sable brushes?

I always prefer good-quality synthetic brushes rather than sable brushes because sable brushes are very soft and are simply not suitable for the kinds of techniques I use. Synthetic brushes are excellent for painting skies and trees:

Here I am using a sable brush to suck clouds out of a wet sky (see page 34).

Look how much more easily and effectively this Cotman synthetic brush draws the paint out of the paper.

A synthetic round brush will hold its point better than a sable round. For the same size brush, the point of a sable will split more readily than that of a synthetic, meaning you have to re-load the brush continually to re-establish the point.

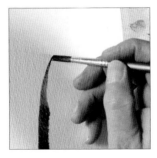
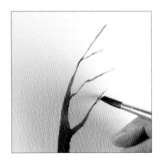

1. Using a no. 8 synthetic round, press hard to achieve a good, broad stroke for the lower branches and trunk of a tree.

2. Gradually lift the brush up and go to a finer point for the smaller branches.

3. Without having to re-load the brush, you can continue painting for some time, producing finer and finer detail.

Which part of the brush can I use?

The simple answer is, all of it. Use different parts of your brush to achieve different effects.

Using a synthetic round

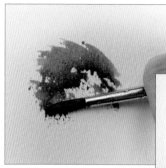

1. Use the side of a synthetic round brush to paint tree tops.

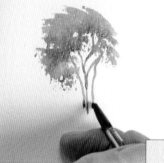

2. With the tip of the brush, add the branches and trunks.

3. Use the side again to put in the grass at the base of the trees.

Using a 2cm (¾in) flat

The side of the brush is good for creating texture – use it to create rough or middle-distance grasses.

Using a 2cm (¾in) flat (continued)

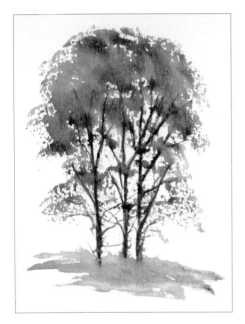

Use the flat of the brush for foliage.

The tip of the brush can be used for sharper lines, such as tree trunks.

Using a rigger

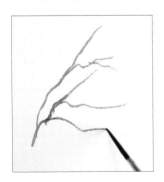

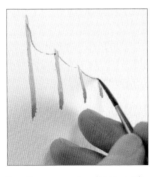

The tip of a rigger is ideal for creating fine, sweeping lines, such as twigs, rigging on ships or telephone lines.

By using the side of the brush and dragging from side to side, you can create the trunk of a silver-birch tree.

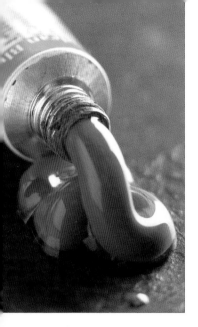

Paints

There are many different types and colours of watercolour paint on the market. This section will help you choose which to buy.

Tubes or pans?

I always use tubes of paint because it is easier to get paint out of a tube quickly than out of a pan. Imagine being on location and you are painting a big sky using a large wash brush. You've pre-wet the paper, which is drying quickly, and you are trying to scrape enough colour out of a little pan to paint with. Using a tube, you simply squeeze out some of the paint and put the water in – it's as easy as that. If the squeezed-out paint dries out on your palette, then simply stroke over it with a wet brush and it is instantly re-useable.

You only need eight colours in your basic palette

All the colours you will ever need can be mixed from these eight colours:

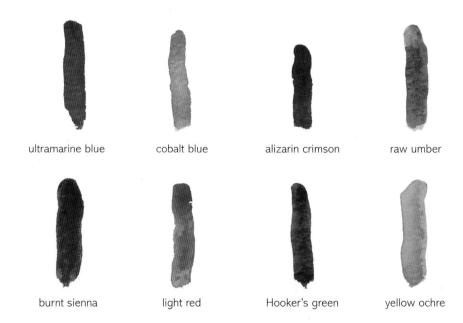

| ultramarine blue | cobalt blue | alizarin crimson | raw umber |
| burnt sienna | light red | Hooker's green | yellow ochre |

16

Should I buy artists' or students' watercolour paints?

Although artists' quality paints are more expensive, I much prefer them to students' quality paints because the pigment is heavier and stronger, and you get a much more intense mix very quickly. With students' quality you have to put nearly twice as much paint into the mix to get the same depth of colour, and, over time, your paintings will tend to fade much more quickly.

You only need one brown

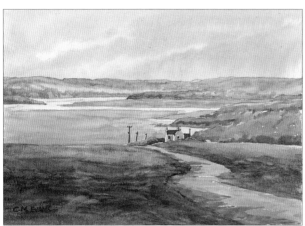

Raw umber is the only brown you will need. All the other browns you need can be mixed by putting different colours into the raw umber, one at a time. For instance, raw umber with a touch of ultramarine blue will give sepia; raw umber with a touch of ultramarine blue and burnt sienna will give Vandyke brown; raw umber and burnt sienna mixed together will give burnt umber.

Hooker's green is the only green you need

All the greens in a landscape can be mixed from Hooker's green. See page 28 for mixing different greens, and page 44 for creating harmony.

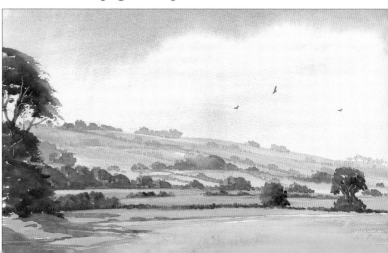

You don't need white paint

If you want white in a painting, leave white paper – this gives the cleanest white there is.

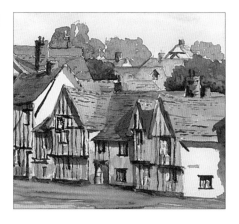

Don't use black paint

Manufactured black paint can look flat. Instead, use a mix of ultramarine blue and burnt sienna.

Why use yellow ochre?

Yellow ochre works well in skies because it doesn't go green readily when it touches blue, and it doesn't 'muddy' when mixed.

1. Place yellow ochre at the bottom of a sky wash using a 2cm (¾in) flat brush.

2. Add ultramarine blue to the top and bring it down into the yellow. Where the two colours mix, a pale blue-yellow is formed, with no hint of green.

18

Palette

How to lay out your palette

I always squeeze out my colours in the same place on the palette, and mix the same colours in the same wells. Some artists like to organize their palette into 'cool' and 'warm' colours, but I prefer to arrange my colours where they are most convenient and comfortable to use.

I have laid out my palette in the same way for 35 years, so it's become second nature where all the colours go!

Use a metal or porcelain palette for mixing

Don't use a plastic palette for mixing your paints. The washes separate out, making it difficult to see the colour you are mixing.

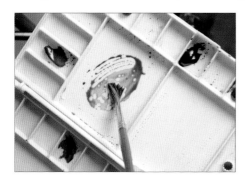

Here I am mixing Hooker's green and burnt sienna on a plastic palette – see how the paint splits.

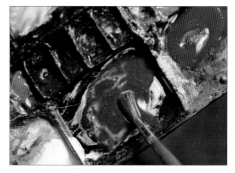

The same colours are being mixed on a metal palette. The paint stays where I put it, without splitting or forming 'beads'.

What else do I need?

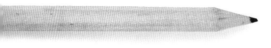

You need a pencil to make your initial drawing

There are many different weights of pencil available, and it is easy to get confused about which weight to use for making your initial drawing. I use a cheap, fairly soft pencil as all I ever use it for is to make a simple, basic outline. Too soft a pencil will smudge as soon as you lay your first wash over it, and a pencil that is too hard will leave an indentation on the paper.

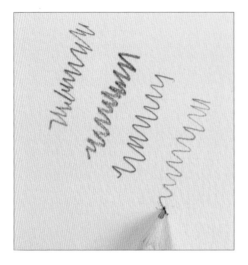

Examples of four types of pencil are, from left to right, 2B, 4B (the softest of the four), B and a pencil that I picked up free in a well-known furniture store – and the one that I use for all my drawing.

Watercolour pencils and a sketchbook

Watercolour pencils are very handy tools, especially for making sketches when you are out on location or on holiday. All you need to take with you is a tin of pencils, a hardback sketchbook and a paintbrush (see page 22).

Masking tape to seal your paper to the board

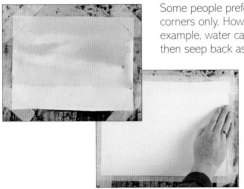

Some people prefer to tape their paper down at the four corners only. However, if you are laying a large sky wash, for example, water can get underneath the paper at the sides, then seep back as the sky dries.

I prefer to tape my paper down all the way round in order to prevent any paint from seeping underneath while I am applying a wash. This stops the paper from cockling, and when I take the tape off the paper dries completely smooth. Also, when you remove the tape from your finished painting you are left with a clean, sharp edge all the way round.

A credit card to create texture ...

A credit card has many different uses. If you are painting on a rough surface, you can achieve some amazing textures and quite often create beautiful colours on the paper (see pages 70–71 and 87–88).

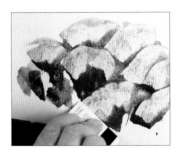

Use the edge of a credit card to scrape rocks out of wet paint.

... and make short, straight lines

If you have a problem painting short, straight lines with a brush, use a credit card instead.

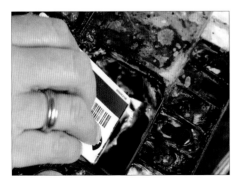

1. Make a strong mix of colour with plenty of water, and dip the edge of the card into the paint.

2. Tap the edge of the card on to the paper, as shown.

SKETCHING

Use watercolour pencils to sketch out your painting in the field

I prefer to use sketches rather than photographs to capture images in the field before painting them in the studio.

1. In most sets of watercolour pencils there is a blue-grey, and I use this to do my outline drawing.

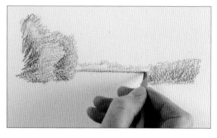

2. Now colour in the main features as if you were using a children's colouring book. Here, I have started with yellow ochre, then added the light green, followed by dark green and finally Prussian blue.

3. For the sky wash, take colour off the watercolour pencil using a wet 2cm (¾in) flat brush.

4. Paint it on to the paper. Here I have used light blue followed by a little Prussian blue. Suck out some clouds using a clean, damp brush, just as you would if you were using paints (see page 34).

5. Wet the rest of the painting and blend the colours.

6. For the water, take Prussian blue off the pencil with a damp brush and paint it on, then wash out the brush, sharpen the tip and suck out some ripples. Two colours can be mixed on the brush, if you wish.

7. With a little dark green followed by a touch of blue and yellow ochre, stroke in a few grasses in the foreground and leave them to dry. The texture helps bring them forward into the foreground.

Use ink to define the main features

Many people ask me what line and wash technique I use, but the truth is I don't. Once a painting is dry, I simply use a black biro to define some of the detail here and there.

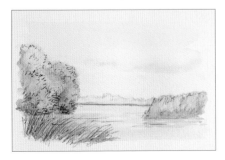

My many sketchbooks contain all the preliminary sketches I have ever made while out in the field. In my view, this is the best way of recording what you see before painting the scene back in the studio.

COLOUR

It is useful to know how to mix the colours you want, and how to adjust them once they are on the paper. To avoid mistakes, always test your mix on a piece of scrap paper first, and allow for the fact that watercolour always dries lighter.

Why do my colours look weak?

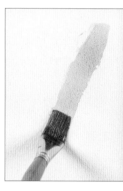

1. You may be making the common mistake of putting large amounts of water into a clean palette before you start mixing colour.

2. You then add the first colour, in this case Hooker's green, followed by more water.

3. Then, after washing out the brush, you add the second colour (here, burnt sienna).

4. The result is a weak, insipid wash.

How can I make my watercolours stronger?

I am always asked how I achieve such strong colours with watercolour. The answer lies in the way I mix them. Always mix the colour first, then water it down afterwards.

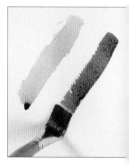

1. I start by putting neat colour straight from the tube into my mixing well.

2. I then go straight to my second colour and add this in too.

3. Finally, I mix the two colours together, adding a little water if necessary.

4. Look how much stronger the colour is than the one I made before.

Adjusting colours and correcting mistakes

You may wish to alter a colour once it is on the paper. For example, you might want to remove some colour in order to introduce light into a painting, or change the colour of a sky.

What to do if a colour is too dark

If you add a colour to your painting that is too dark, you can stroke out the dry colour with a damp brush.

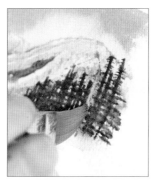

2. With the tip of the brush, stroke the dry painting and lift out the paint. In this way, you can reveal light without having to use masking fluid, which can often give too hard and sharp a line.

1. Take a damp, 2cm (¾in) flat brush and squeeze the tip between your fingers to sharpen the end.

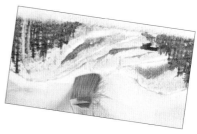

How to lighten a sky

To lighten the sky in a picture, or to remove a mistake, turn the painting upside-down first then re-wet the area. This allows the paint to run towards the top edge of the painting, keeping the bottom part untouched. Lift out the excess colour with a clean, damp brush.

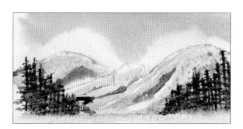

Before lightening

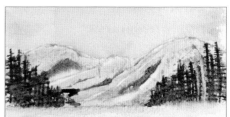

After lightening

Colour mixing

Some useful mixes

Generally, when starting to paint, many people think you need to buy as many different colours as you can lay your hands on, but this simply leads to confusion, and a lot of very muddy mixes. Instead, stick to just a few manufactured colours and mix all the other colours you need from them. As you grow in confidence with your colour mixing, you can add other colours to your collection if you need to.

My palette of eight colours (see page 16) has served me well for over 35 years. Here are some of my 'tried-and-tested' mixes that I have found most useful:

Black

Never use a manufactured black – a much more interesting dark can be achieved using ultramarine blue and burnt sienna.

Skin tone

To make a realistic skin tone, mix yellow ochre with a tiny dot of light red and ultramarine blue. Darken with a touch more light red if necessary.

Sand

One of the mixes I use most often for beaches is yellow ochre, raw umber and a touch of ultramarine blue. This colour also works well for light stonework.

Grey

Take the same mix as used above for beaches, add some more ultramarine blue and you have a good grey that you can use for anything from stonework to the trunks and branches of silver-birch trees.

Overcast sky

For an overcast sky, use ultramarine blue and a touch of burnt sienna.

Sunset sky

Yellow ochre with a touch of light red gives a gorgeous orange glow for the central area of a sunset sky.

Shadows

Your shadow colour should include the same blue as you have used in the sky.

If your sky contains ultramarine blue, your shadows should be a mix of ultramarine blue, alizarin crimson and a touch of burnt sienna.

If you have used cobalt blue in the sky, then the shadow mix would be cobalt blue, alizarin crimson and a touch of burnt sienna.

For a warm shadow mix, use cobalt blue mixed with light red.

Mixing greens

I only have one green in my palette, Hooker's green (see page 16).
I do not use it on its own, but mix it with a lot of other colours in
my palette to create many beautiful greens. By basing all my greens
on Hooker's green, I create harmony in my landscape paintings
(see page 45).

The mixes below all consist of Hooker's green mixed with the
colour or colours named.

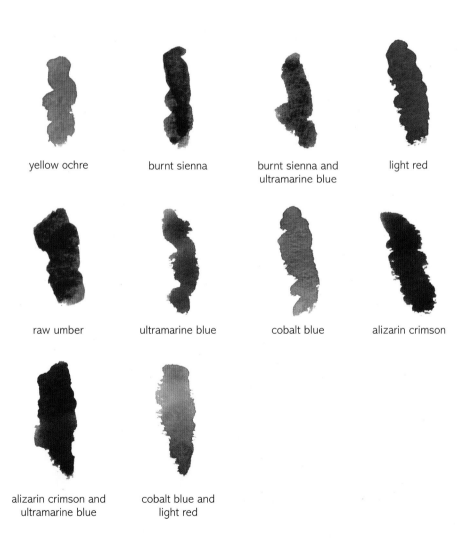

yellow ochre burnt sienna burnt sienna and
ultramarine blue light red

raw umber ultramarine blue cobalt blue alizarin crimson

alizarin crimson and
ultramarine blue cobalt blue and
light red

Mixing browns

Raw umber is the only brown you need to buy. If you add ultramarine blue to raw umber you can make sepia, and if you then add some burnt sienna to the mix you can make Vandyke brown. Adding burnt sienna to raw umber gives burnt umber – four browns from just one tube of paint!

| raw umber | raw umber and ultramarine blue | raw umber, ultramarine blue and burnt sienna | raw umber and burnt sienna |

Mixing yellows

Raw sienna is less opaque than yellow ochre and many people prefer to use raw sienna for this reason. However, you can achieve the colour and transparency of raw sienna by following the steps below.

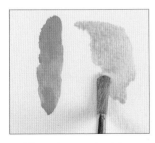
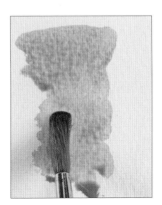

2. Here I have made my own raw sienna by adding a tiny touch of raw umber and plenty of water to yellow ochre.

1. The colour on the left is neat yellow ochre – a strong, opaque colour. On the right I have mixed it with lots of water to make it more transparent.

SKIES

When painting a landscape, once the drawing is done I always start the actual painting by doing my sky first because it sets the mood and the atmosphere of the whole painting. Once the tone of the sky is set and the paint has dried, you will automatically paint the rest of the picture to match it.

In this section I will show you how to paint all different kinds of skies, but the first thing to master is how to lay a wash. The initial wash can make or break a good sky, so it's important to practise the technique well so that you can then paint your skies with confidence, without the fear of your painting being ruined before it has even started.

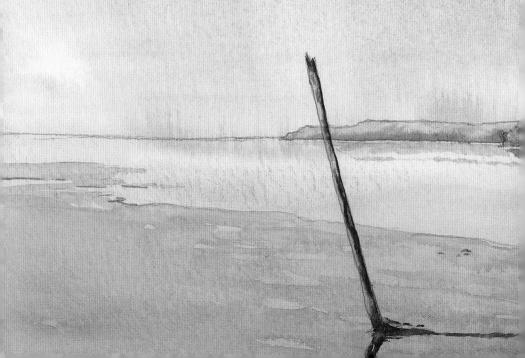

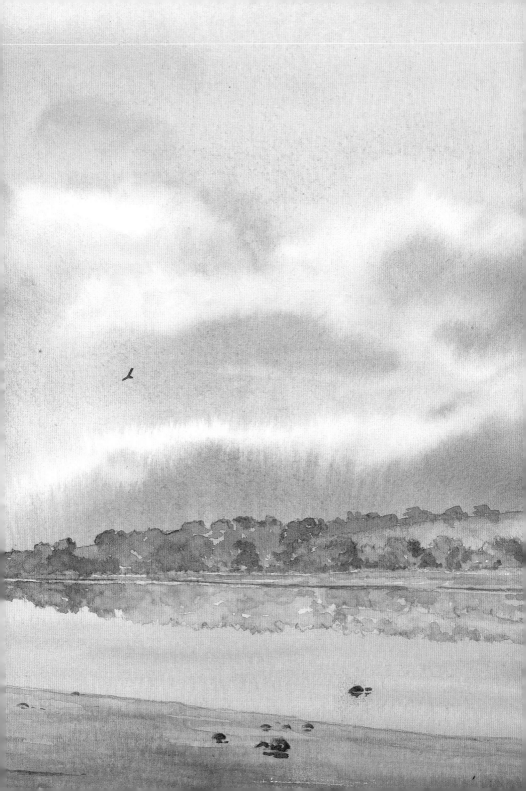

Laying the basic washes

1. Pre-wet the paper using a 2cm (¾in) flat brush. With a little yellow ochre mixed with a touch of burnt sienna, just touch the base of the wet area.

2. While this first wash is still wet, bring in a second wash of cobalt blue with a tiny touch of burnt sienna. Pull this wash down into the yellow.

3. Continue blending the two washes to achieve the desired effect.

Turning the basic wash into an overcast sky

Turn your basic washes into an overcast sky following the simple steps below.

1. Add more cobalt blue with a little burnt sienna mixed in using the tip of the flat brush.

2. Squeeze out the brush. Now lift out some clouds using the corner of the brush.

Laying a graduated wash

A graduated wash is simply one in which the colour gets weaker as it goes from the top to the bottom of the painting. It is imperative, when laying a graduated wash, that you angle your board so that the colour runs down the paper.

1. Pre-wet the paper using a 2cm (¾in) flat brush then, with a little ultramarine blue, apply a fairly strong wash at the top of the paper.

2. Without adding any more colour to the brush, pick up a little water and continue on down until the colour fades out completely.

Laying a variegated wash

This follows the same sequence as a graduated wash, but with the introduction of a second colour.

1. Pre-wet the paper and lay a graduated wash using cobalt blue. Take the wash right down to the base of the pre-wetted area.

2. Bring in a touch of light red at the bottom and blend it upwards into the blue.

3. Finish with a line of fairly clean light red at the base and blend it in to the lower red area.

How to paint a blue sky with fluffy clouds

1. Pre-wet the paper using a 2cm (¾in) flat brush, then lay a graduated wash of cobalt blue (see page 33).

2. While the wash is still wet, squeeze out the brush and suck out the clouds in swirling movements.

3. Add a hint of light red to the cobalt blue and drop the mix into the base of the clouds. Add the cloud shadow to the lower part of the clouds and soften it in.

How to create wispy clouds

2. Squeeze out the brush and use the tip to suck out the clouds.

1. Pre-wet the paper using a 2cm (¾in) flat brush, then lay a variegated wash of ultramarine blue at the top and yellow ochre mixed with a little light red at the bottom (see page 33).

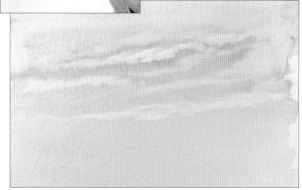

3. Continue until the desired effect is achieved.

How to paint a Mediterranean sky

All that you need for this type of sky is a warm blue and a few wispy clouds.

1. Begin by pre-wetting the paper and laying a graduated wash of cobalt blue with just the tiniest hint of alizarin crimson added to it (avoid the mix becoming purple).

2. Clean the brush and squeeze it out, then, with the tip of the brush, lift out the merest hints of cloud.

3. Add a little more alizarin crimson to the mix and drop in a little cloud shadow in the lower part of the sky.

4. Smooth and blend the colours with the edge of the brush.

The completed sky.

How to paint a stormy sky

Follow the same method as for blue skies, but use more, and stronger, colours. This means you have to paint faster! As before, use a 2cm (¾in) flat brush.

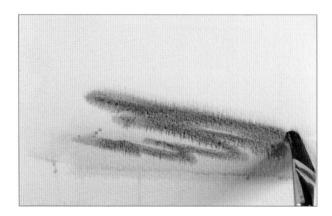

1. Pre-wet the sky area and lay the first colour towards the base of the picture, in this case a little yellow ochre. Mop up excess paint with a damp brush, then add in some burnt sienna.

2. Lay a mix of ultramarine blue and burnt sienna into the top part of the sky.

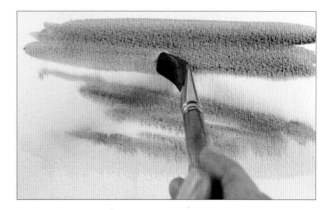

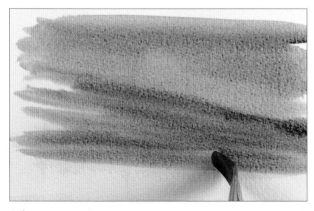

3. Pull it downwards into the other colours, working with horizontal brushstrokes.

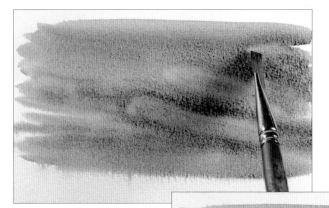

4. Add a touch of raw umber to the right-hand part of the sky, towards the top. Move the paint around and merge it gently with the other colours.

5. Wash the brush, squeeze it out and suck out some clouds.

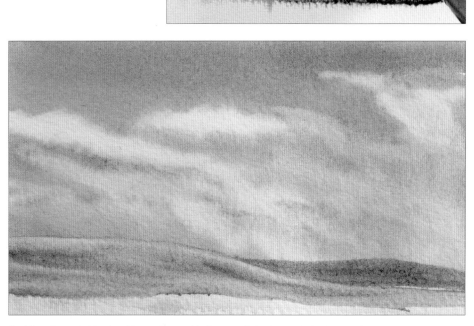

6. Allow the paint to dry. I have then added some distant mountains to create a bleak, foreboding landscape.

How to paint a sunset sky

Many people are nervous of painting sunsets, but there is really no need to be. They are just as easy as other skies, but using more vibrant colours.

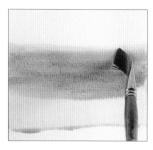

1. Start with a pre-wash of watery yellow ochre, then lay in a stronger mix of yellow ochre at the bottom. Above this, lay a band of light red, again a good, strong mix, and blend the two colours together.

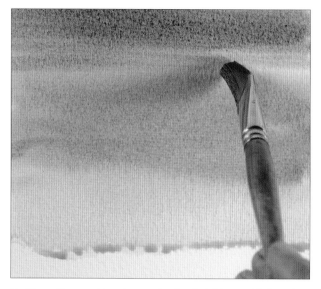

2. Above these, add a strong mix of cobalt blue and light red, and soften it into the colour below.

3. Introduce some of this colour into the lower parts of the sky.

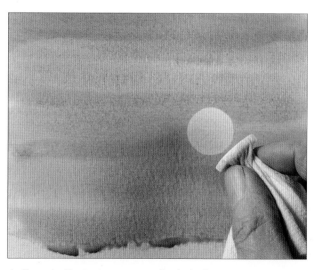

4. To make the sun, wrap a small coin in tissue paper or paper towel – make sure it is wrapped tightly – then simply press it on to your picture in the required position and lift off the paint.

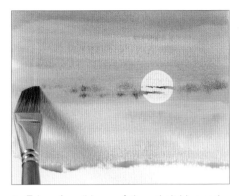

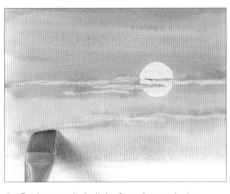

5. Take a few ribbons of the cobalt blue and light red mix across the sun using the corner of the brush.

6. Suck out a little light from beneath the clouds using a damp brush.

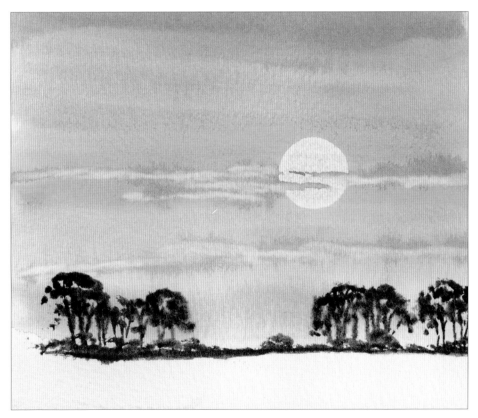

7. I allowed the sky to dry, then added some trees to the horizon line using a dark mix of ultramarine blue and burnt sienna.

Effect of the sky on the landscape

Look at the two paintings below – two almost identical scenes but with totally different skies. You can see instantly how the sky affects the light, mood and atmosphere of the paintings. Notice the differences in the shadows in the foreground areas, especially on the path and in the dark, rich, mossy grasses. Also notice how the sky affects the light on the beach, the path and on the distant hills. The water is also slightly darker in the lower picture and the shadow is stronger on the building in the middle distance. Everything is affected by the sky, and the overall tone of the lower picture is darker than that of the one above.

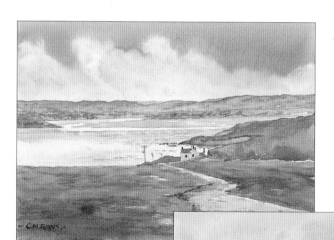

Scottish Highlands scene with a light blue, fluffy sky.

The same scene with a more overcast sky.

CREATING DEPTH

Creating a sense of depth is a vital aspect of landscape painting. It turns your painting from a two-dimensional representation on paper into a three-dimensional scene that draws the viewer in. It can be achieved easily using various techniques, which are not difficult to master and which are explained briefly here.

How to create depth using paths and fences

Notice the strong sense of depth and recession within the painting below. The part of the sky towards the top of the painting (the part that is nearest the foreground) is a good, strong, overcast sky, and in the distance it is a lot lighter, but the real depth is created by the horizontal path that gets much narrower as it disappears into the far distance. The sense of distance is further enhanced by the vertical snow posts on the left side of the path, which get shorter and less distinct as they go further away into the distance.

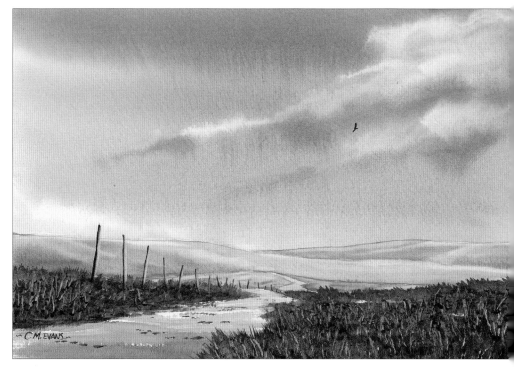

C.M. EVANS

How to make objects recede into the background

To obtain a hazy look, paint the distant elements while the sky is still slightly wet. Use pale, weak colours and put the same blue that is in the sky into the background – a blue glaze pushes things further back. I usually use ultramarine blue. Avoid putting too much detail into the background – detail can be intimated, but not painted in. Avoid using green.

How to paint elements in the middle distance

As I come further forwards in the painting towards the middle distance, my colours get slightly stronger and I put a touch more detail into some of the elements that I am painting, such as some bushes tucked behind the building here. Slightly more detail and depth of colour bring these elements forward.

Bringing elements forward into the foreground

As I come into the foreground area of the painting, I introduce much more detail and the colours get much stronger; in this way I create more depth. Take, for instance, the grasses. In the middle distance and the far distance the grasses are just intimated with the swish of a brush. In the foreground, however, I am actually flicking the brush upwards to create individual blades and tufts of grass here and there.

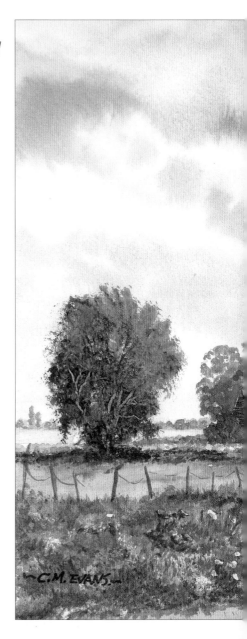

C.M. EVANS

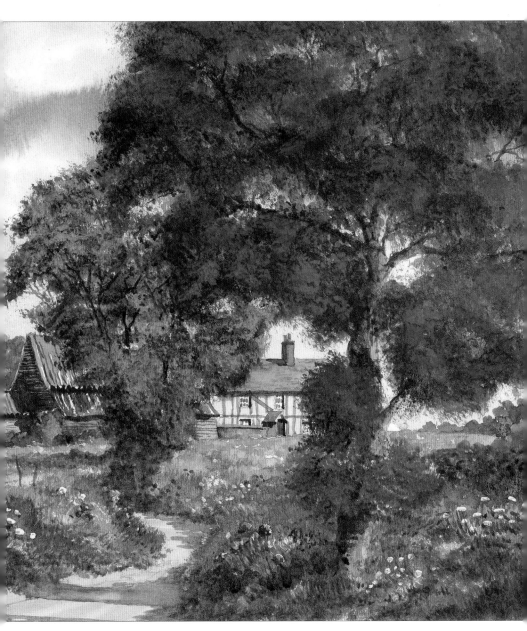

This composition is a classic 'L' formation, with the tall tree taking up the whole of the right-hand side and a horizontal band of land going across the base of the picture. Extra interest is added with the view of the front of the cottage glimpsed through the gaps in the foreground trees, and the little buildings to the left of the middle-distance tree. Taking the viewer towards the background elements is the path, which is fairly wide in the foreground and gets narrower as it twists off into the middle distance.

INTRODUCING HARMONY

Never change the blues you are using during a painting

The blue that is in your sky should be the same blue that goes into your trees, your grasses, your water, and so on. This will keep your painting in harmony. The only exception to this would be if you wanted to use black somewhere in the landscape, in which case I would use a mix of ultramarine blue and burnt sienna no matter what blue I had used elsewhere.

In the first of the two paintings below, I have used cobalt blue in the sky and ultramarine blue in the water. The resulting picture lacks cohesion – it just doesn't look right. In the painting below it I have used the same blue, cobalt blue, for the sky and for the water. The result is a harmonized painting, in which the colour of the sky is reflected in the water.

Lakeland scene using opposing blues.

Same Lakeland scene using the same blues.

When painting a patchwork of fields or a forest, use the same green throughout

Some artists would paint a forest scene using a huge range of different greens, but when you look closely you realize it is made up of patches of unrelated colours, all somehow contradicting each other; the painting is not in harmony.

To avoid this, I mix all of my greens based on one colour only, which is Hooker's green. With a little of another colour mixed into it, or sometimes two colours, I can achieve all the greens I need for a landscape painting and, because all of the greens are based on the same colour, the painting is in harmony yet still has plenty of variety.

Take the picture below, which is the view from the field behind my house in Northumberland. There are a lot of different greens in the foreground, middle distance and distance, but they are all based on Hooker's green.

What is Hooker's green?

Hooker's green is a fabulously versatile green that is made for mixing, which is exactly why Mr Hooker had it made for him in the early Victorian days. Mr Hooker was a botanist who travelled around the world cataloguing and logging plants and making coloured drawings of them. He wanted a green that he could mix easily with other colours while out in the field, without having to use the powders and other paraphernalia that were usually involved in those days. So Hooker's green was invented, and I use it for exactly the same reason as Mr Hooker — for mixing greens.

LIGHT AND SHADE

It is important to bring some form of light into your paintings through the careful use of colour and shadows, otherwise you will end up with a picture that is flat and dead-looking.

Showing the direction of light

Always observe your subject before painting it and decide where you want the light to come from.

1. Begin by laying a warm, variegated wash using a large wash brush. Put in the mountains on the horizon using yellow ochre with Hooker's green over the top. Leave yellow ochre on the peaks and on the left-hand side of each mountain to indicate light coming from the left.

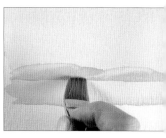

2. Lift out some of the colour from the lighter areas to lighten them even more.

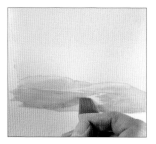

3. Using a slightly stronger mix of yellow ochre, start putting in the middle- and foreground, leaving a path through the middle. Add some of the Hooker's green mix over the top.

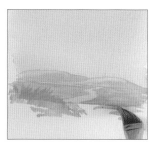

4. Change to a smaller wash brush and 'flick up' a few grasses in the foreground using yellow ochre.

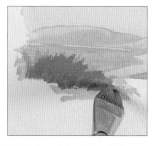

5. Follow this with a fairly strong mix of Hooker's green and yellow ochre.

46

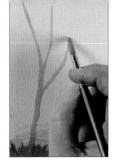 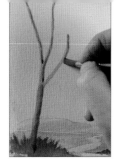 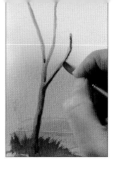 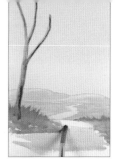

6. Using yellow ochre and a round brush, map in a tree on the left of the painting. Start at the base and work up to the finer branches.

7. Run a darker colour, raw umber, to the right of the yellow ochre. Do this while the first colour is still wet so that they blend into each other.

8. Now mix some ultramarine blue and burnt sienna so it is virtually black and run this to the right of the other two colours. The tree now appears lit from the left.

9. Add a little raw umber to the foreground.

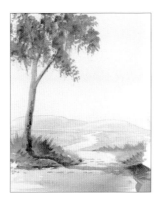

Creating shadows

Always use the same blue in the shadow mix as you use in the sky.

10. Stipple on the foliage using a 2cm (¾in) flat brush. Start with yellow ochre, then a Hooker's green and burnt sienna mix. Finish with a tiny touch of cobalt blue to add depth.

11. Make a shadow mix using cobalt blue, alizarin crimson and a touch of burnt sienna. Run it down the right-hand side of the trunk and across the path to the right-hand side of the picture. Also place a few more shadows into the grasses.

12. Finish by putting a more watered-down version of the shadow mix on to the right-hand sides of the distant mountains.

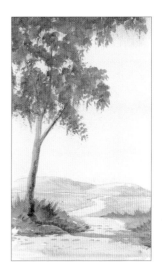

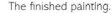

The finished painting.

Using light to create drama

The best way to lift a painting and add vibrancy and drama is to add strong light. Strong light is often helped by contrasting it with strong dark. The best place to put a strong, dark shadow is next to a strong light. This will never fail to add interest and drama. Look at the waves in the seascape below, for example.

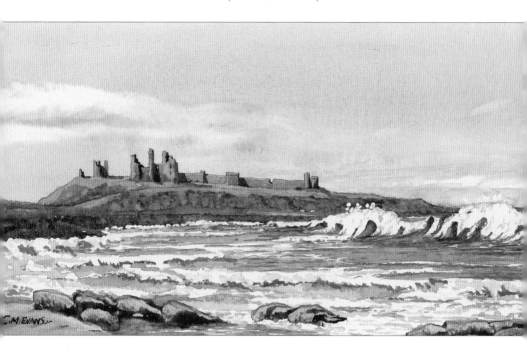

Creating dappled light

Dappled light is created under trees when the sun is shining, evoking a warm, summery feeling. To achieve it, simply leave little gaps in amongst the shadows beneath the foliage rather than making a solid, hard shadow. Dab and stipple the paint on, leaving little gaps in between, as shown in the picture on the left.

Painting realistic shadows

Having to put a strong, hard, dark line across a painting is a daunting prospect for most artists, especially as it is one of the last things you do to a painting that you may have laboured over for many hours. The secret is to be confident, as strong shadows, when coupled with strong lights, will really bring your painting to life. Don't be afraid to cast a good, strong shadow across a street or a path. Identify the location of the light source and apply the shadows and lights consistently for a realistic effect. In the mix itself, include the colour over which the shadow is cast, and ensure you leave a little bit of light showing here and there to give the shadow form.

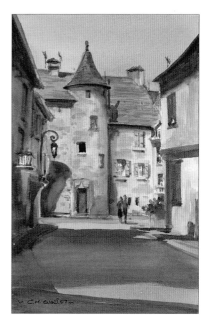

Painting sunbeams

The most important aspect of painting sunbeams is the sky itself, which must be light at the bottom, towards the horizon, and have strong, dark, hard clouds at the top. These will provide somewhere for the sunbeams to emerge from. Once you have achieved the right sky, wash out your 2cm (¾in) wash brush, dry it out and simply suck out some straight lines from the still-wet sky.

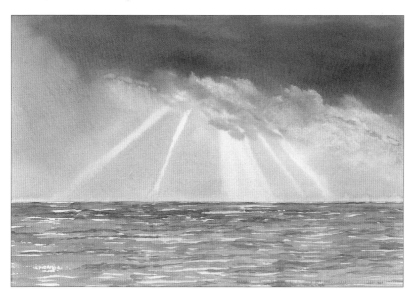

49

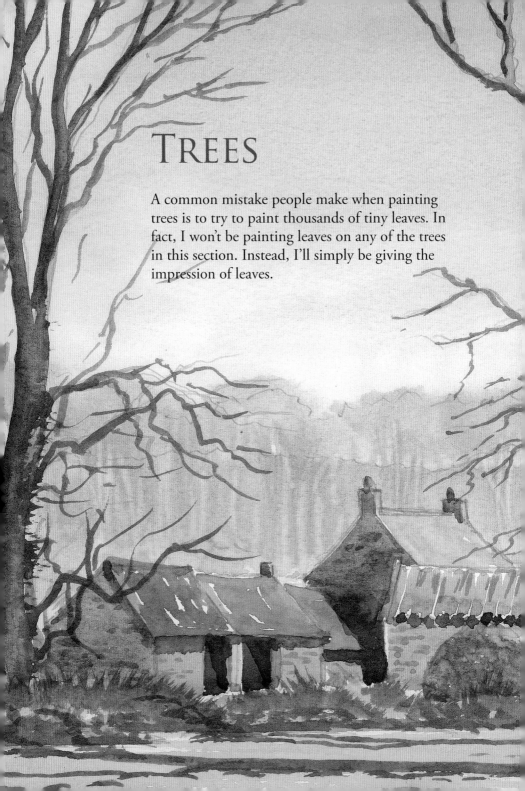

TREES

A common mistake people make when painting trees is to try to paint thousands of tiny leaves. In fact, I won't be painting leaves on any of the trees in this section. Instead, I'll simply be giving the impression of leaves.

Painting middle-distance trees

Here is an easy way to paint middle-distance trees using a 2cm (¾in) flat brush.

1. Using a mix of Hooker's green and burnt sienna, hold the brush so that the ferrule is also touching the paper and tap on the paint.

2. Add a little more burnt sienna to the mix and, using the very tip of the brush, drag in a few fine branches and the trunks.

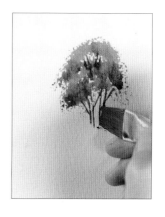

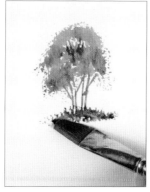

3. Now use the side of the brush to tap in a few grasses at the base of the trees to ground them.

How to paint a foreground tree

When painting a large foreground tree, the temptation is to add as much detail as possible, and to overwork the trunk in an attempt to give it a rounded appearance. However, the more work you put into a painting, often the flatter it will look. The secret is to paint quickly, and avoid too much detail.

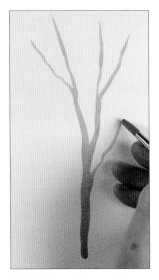

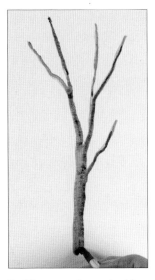

1. Starting with a round brush and a little yellow ochre, paint in the rough outline of the tree.

2. While the paint is still wet, use the same brush to put a little raw umber down the right-hand side of the tree. The colours will immediately blend into each other, with no hard edge, resulting in a rounded appearance.

3. Mix some ultramarine blue with burnt sienna, and lay a strong shadow down the right-hand edge of the tree.

4. Change to a rigger and, continuing with the same dark mix, place a few brushstrokes on the side of the tree. Use the side of a rigger to tap into the colours of the tree trunk and give it some rough texture.

5. Put in the fine branches at the bottom of the tree, using the same colour and brush.

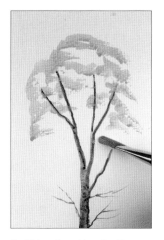

6. Using the side of a 2cm (¾in) flat brush and yellow ochre, tap on the foliage. Even though this is a foreground tree, there is no need to paint individual leaves.

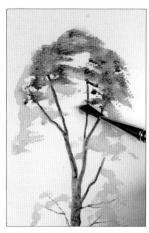

7. Next put on some Hooker's green mixed with burnt sienna in the same way.

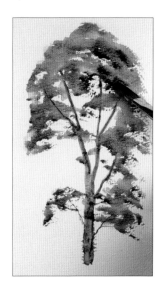

8. Bring in a little shadow with some ultramarine blue added to the mix, again applied with the side of the brush. Put it mainly on the side of the tree away from the light.

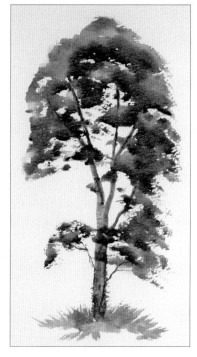

9. Seat the tree on some grass, brushed in with a mix of Hooker's green and burnt sienna.

53

How to paint a winter tree

Winter trees are, again, very simple. If you are painting a snow scene, keep the trees really dark so that they contrast well with the white snow. Use a mix of ultramarine blue and burnt sienna.

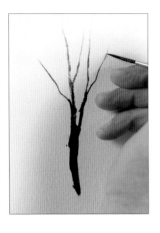

1. Starting with a rigger brush, paint the trunk by pressing firmly on the brush so that the hairs spread out and give a broader stroke. As you take the paint upwards, lift the brush so that the strokes get thinner.

2. When you have put in the main branches, lay the full length of the rigger on the trunk and flick outwards to create some detail and texture lower down.

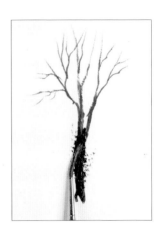

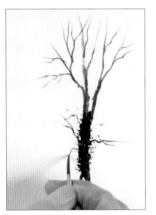

3. Use the tip of the brush to pull out a few finer twigs.

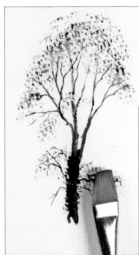

4. Change to a 2cm (¾in) flat brush and, just as you did on the middle-distance tree (page 51), tap on the foliage using the full length of the brush head.

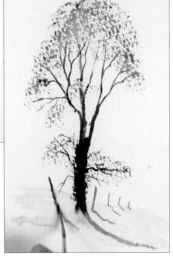

5. Add a touch of blue, a few fence posts receding into the distance and some shadows, and you have created a simple snow scene.

How to paint autumn trees

Begin, as you did with the winter tree, by putting in the main trunks and branches using a rigger brush.

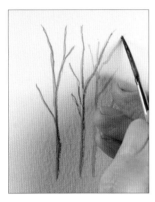

1. Create the main outlines using yellow ochre, then add a line of raw umber mixed with burnt sienna just to the right of the yellow.

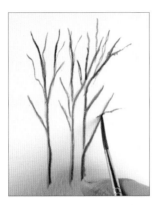

2. Now, with a dark mix of ultramarine blue and burnt sienna, go down the right-hand side of the trunks and branches, as shown.

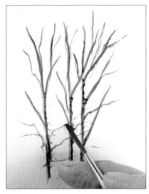

3. With the dark mix, put in a few fine strokes here and there coming off the sides of the trees.

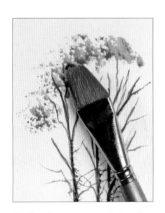

4. For the canopy, start with a mix of yellow ochre and burnt sienna, and tap on the colour with the flat of a 2cm (¾in) wash brush.

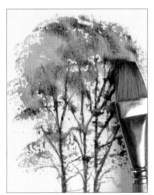

5. Dab a little of a darker mix (ultramarine blue and burnt sienna) on to the right-hand side of the foliage only.

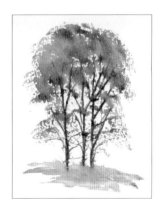

6. Finish by putting a little of the yellow ochre and burnt sienna mix underneath the trees, and adding a shadow.

Ivy-clad trees

Rather than attempting to paint thousands of tiny leaves, create the impression of ivy using a split round brush to stipple on the colour.

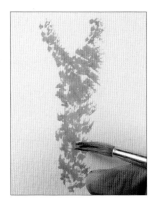

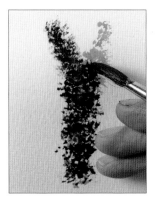

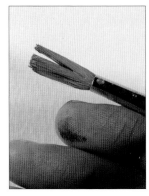

1. Begin by stippling on the ivy using yellow ochre.

2. Stipple on a mixture of Hooker's green and burnt sienna over the top, making sure you leave a little of the yellow showing through here and there.

A split no. 8 round brush.

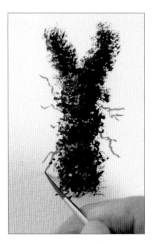

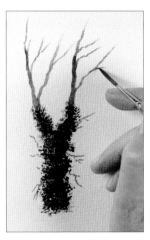

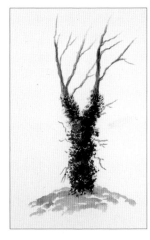

3. Use a dark mix of ultramarine blue and burnt sienna to stipple on the darkest leaves on the right-hand side of the tree. Use a rigger to pull out fine twigs.

4. Pull out some branches at the top of the tree too. Add a touch of ultramarine blue and burnt sienna to the right-hand sides of the upper branches.

5. Finish by grounding the tree on some grass using a mix of Hooker's green and burnt sienna.

A line of poplar trees

Poplars are very simple trees to paint, and are excellent for getting depth into a painting when placed in a receding line.

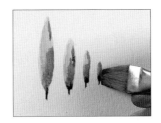
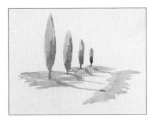

1. Using the 2cm (¾in) flat brush, begin by painting a row of 'bananas' using yellow ochre.

2. While the paint is still wet, and using a mix of Hooker's green and yellow ochre, paint in the right-hand sides of the trees and pull down the trunks. Add a touch of ultramarine blue to the lower right-hand edge.

3. Place some grass beneath the trees using Hooker's green and yellow ochre mixed. Leave a path through the middle. Lay some shadows across the path, and you have a French country lane.

Scots pine

Scots pines are very effective trees in a landscape. They have a strong shape but are very easy to paint.

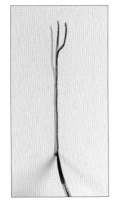
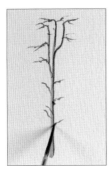
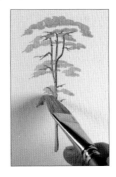
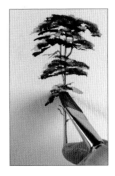

1. Using a rigger, paint a tall stick with two or three branches at the top. Use yellow ochre, then add ultramarine blue and burnt sienna down the shaded (right) side.

2. Add some fine branches to the top and sides of the tree – those at the top are more prominent than the ones lower down.

3. Change to a 2cm (¾in) flat brush and tap on the foliage using yellow ochre.

4. While the paint is still wet, dab on a mix of Hooker's green, burnt sienna and ultramarine blue over the top.

57

Weeping willow

Weeping willows, in common with every other tree, begin with a trunk, but the branches hang down, giving the tree its characteristic shape.

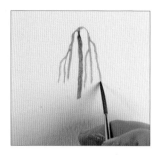

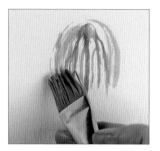

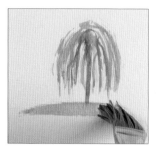

1. Paint the trunk and main branches using a rigger brush and a mix of raw umber with a touch of yellow ochre.

2. Using a mix of Hooker's green and yellow ochre, split a 2cm (¾in) flat brush and use downward brushstrokes to put in the foliage, as shown.

3. Finally, add a base for the tree to stand on.

Fir tree

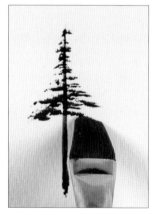

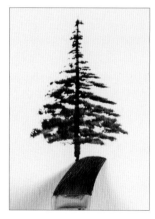

1. Mix some Hooker's green, burnt sienna and ultramarine blue to make a dark green. Using the tip of a 2cm (¾in) flat brush, drag the brush down to make a trunk that is slightly broader at the bottom than the top.

2. Starting with the corner of the brush, tap on the paint at the top of the tree and work downwards, turning the brush as you go so that more of it is in contact with the paper.

3. When you reach the bottom of the foliage, go back and fill in the gaps where needed, still using the tip of the brush.

58

Palm tree

Palm trees are easy to paint, and give a tropical or Mediterranean feel to a landscape.

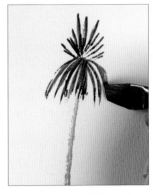

1. With the rigger brush and a mix of raw umber and yellow ochre, simply drag the brush down the paper to create the trunk. Place a line of dark down one side.

2. Make a mix of Hooker's green, burnt sienna and ultramarine blue and use the tip of a 2cm (¾in) flat brush to put in the foliage.

Fruit tree in blossom

Begin by applying masking fluid where you wish the blossom to go, then once it is dry paint the trunk, branches and foliage using a 2cm (¾in) flat brush. When the paint is dry, rub off the masking fluid and touch in the blossom using a weak mix of rose madder or alizarin crimson. Leave a few white highlights.

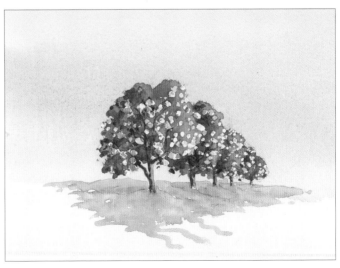

How to paint a windswept tree

A windswept tree can be used to create atmosphere in a painting. To achieve a sense of movement, simply bend the tree over in the direction of the wind.

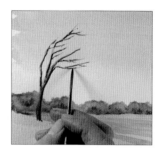

1. First paint a simple background using yellow ochre, ultramarine blue and light red. Using a rigger brush, paint in the tree from the bottom up with yellow ochre.

2. Apply a strong mix of raw umber to the right-hand side of the trunk and branches.

3. Darken the shadow further to the right of these colours using a mix of ultramarine blue and burnt sienna.

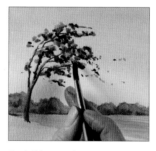

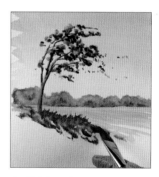

4. With a no. 8 round brush, stipple on the leaves using yellow ochre, taking some off into the air to the right of the tree.

5. Add some burnt sienna in amongst the yellow leaves. Follow this with a little ultramarine blue mixed with burnt sienna.

6. Finish with a patch of grass underneath the tree to seat it firmly in the foreground. Start with yellow ochre, then Hooker's green mixed with light red. Touch the colour on with the tip of a 2cm (¾in) flat brush.

How to paint a thicket

A line of trees or shrubs receding into the distance is a useful feature for creating depth in a landscape.

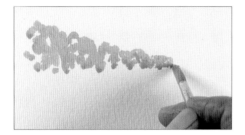

1. Using a round brush and a little yellow ochre, stipple on the paint to create the line of receding shrubs. Notice how the line steadily narrows as it gets further away.

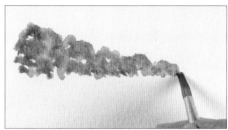

2. With a mix of Hooker's green and burnt sienna, stipple on a second layer of colour, so that some of the first colour still shows through.

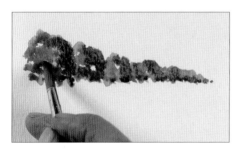

3. With a tiny touch of ultramarine blue, split the line into individual shrubs by adding the blue to the right-hand side of each one, as shown.

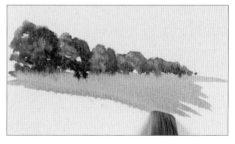

4. Using a fairly strong mix of yellow ochre and a 2cm (¾in) flat brush, put in the ground, curving each brushstroke downwards to suggest the land sloping down and away.

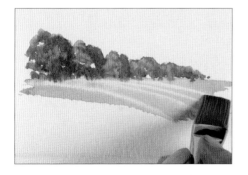

5. Wash out the brush, squeeze it out to sharpen the tip and suck out a few lines of paint to give the land more texture.

LIFE IN THE LANDSCAPE

Putting people and animals into a landscape can bring your painting to life and add a sense of scale. In this section I will show you some simple tricks for painting realistic people and animals.

People

How to draw people in the distance

You can enhance a landscape by adding people to it, but remember that they should not be the main focus of attention, so avoid adding too much detail. Placing them in the distance, walking away from you, is an effective way of adding life to a landscape. To start, all you need is a Y, a P and a full-stop.

1. For two people, start with two full-stops.

2. Write a 'P' under the right-hand one, with a short 'tail'.

3. Fill it in, then write a similar 'P', this time back-to-front, under the left-hand full-stop.

4. Fill it in, then write a 'Y' under the first 'P'.

5. Repeat on the other side, fill them in and place the two figures on the ground.

To add a dog ...

 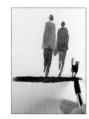 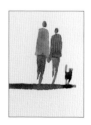

1. Draw a square.

2. Fill it in.

3. Draw a smaller square on top.

4. Add just two legs and a tail ...

5. ... and you have a couple walking a dog!

How to draw a crowd advancing towards you

Begin with a single, prominent figure, then add some less distinct people behind it. For the flesh tone, use yellow ochre, light red and a touch of ultramarine blue; the rest of the figure is clothing.

1. Place three spots of flesh tone on the paper, at the corners of an imaginary triangle.

2. Paint in the jacket, with the 'spots' forming the hands and the head.

3. Now add the trousers. For each foot, leave a gap at the base of the leg then put in another spot of paint underneath.

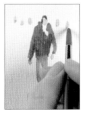

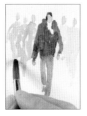

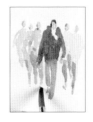

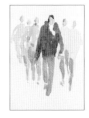

4. Add the hair, and a little more shading to the clothes.

5. Place a few flesh-coloured spots behind the figure, on either side.

6. Use pale mixes to put in the clothes.

7. Add some slightly stronger shadows.

A crowd of people walking towards you.

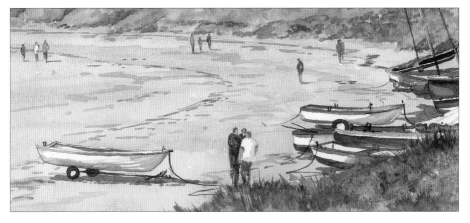

Here I have used people to lend a sense of scale and perspective to this painting of a beach.

Animals

There are some very simple ways of painting farm animals. Like people, they can be used effectively to add a sense of scale and perspective to your painting.

How to draw cows

1. Simply start with three triangles. Add a triangle for the head and a line for the tail.

2. Add markings with ultramarine blue mixed with burnt sienna.

3. Put in some shadows using a very pale grey mix.

4. Finally, paint the tail.

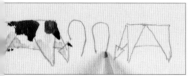 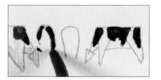 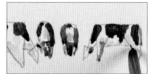

5. For a herd, grazing in the middle distance, add another cow facing the first, then draw two oval shapes in between them.

6. For variety, paint some of them using raw umber and burnt sienna.

7. Add some black and shadows, as before.

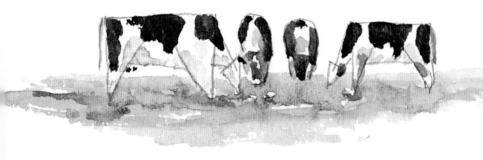

How to draw sheep

1. Begin with three sides of a loaf of bread, then add a square head at one end, as shown.

2. Paint the sheep using a little yellow ochre followed by some ultramarine blue and burnt sienna mixed with plenty of water.

3. Stipple and blend the colours together with a clean, damp brush.

4. Use a strong version of the black mix for the face, and lay a patch of grass underneath to finish.

How to draw flying geese

 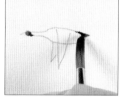

1. First draw a bottle of wine lying on its side.

2. Next, draw a small triangle at each end.

3. Add two more triangles, one on each side of the bottle, for the wings.

4. Add a little black at each end, using ultramarine blue mixed with some burnt sienna.

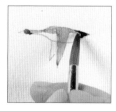 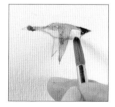 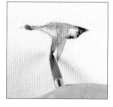

5. Paint the upper part of the bird and the front wing using raw umber and burnt sienna mixed.

6. Put a shadow underneath using a pale grey wash.

7. Use a stronger version of the same grey for the other wing and for the underside of the bird.

8. Finish with a beak of yellow ochre.

Painting a foreground dog

With the addition of a little more detail you can bring an animal further forward in your composition. Here I will show you how to paint a lively springer spaniel that looks complicated, but is actually very easy to paint.

1. Make a pencil outline, and indicate where you wish the markings on the dog's body to go.

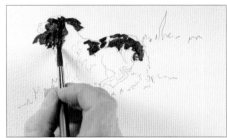

2. Start with a mix of raw umber, burnt sienna and a little ultramarine blue, and paint in the brown parts of the dog.

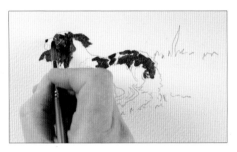

3. With a touch of black, put in the nose and the eye.

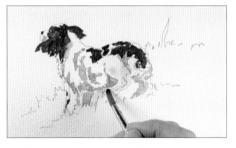

4. Use the same mix but with plenty of water added for the shadows. Vary the strength of the mix to create light and dark shadows.

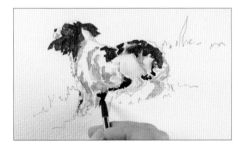

5. Allow to dry, then darken the mix so that it is almost black and put in the strongest shadows on the dog's belly.

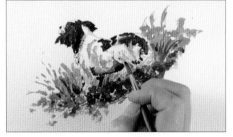

6. Finally, add the grass using Hooker's green and burnt sienna, once again varying the strength of the mix to obtain a variety of shades of green.

Painting pheasants in flight

As before, start with a simple pencil outline and map in where you wish to place the shadows.

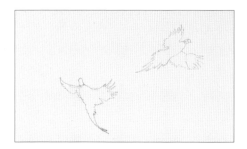

1. Make your drawing, and mark on the main shadows.

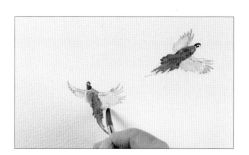

3. With a paler version of the same mix, add some brown highlights to the wings. Mix a touch of ultramarine blue with plenty of water for the undersides of the wings, leaving a few tiny patches of white here and there.

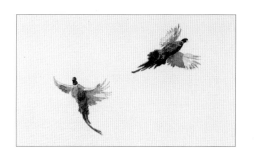

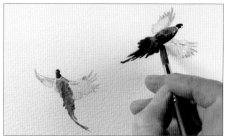

2. With a mix of ultramarine blue and Hooker's green, put in the heads using a no. 8 round brush. Then paint in the bodies using a mix of raw umber and burnt sienna.

4. With the tip of the brush, put in the red markings on the birds' heads using alizarin crimson, then add the shadows to the birds' bodies using a mix of ultramarine blue and burnt sienna. Take the shadow colour down into the long tail feathers.

The finished birds.

Painting horses

Many people are daunted by the prospect of painting horses, but by breaking them down into a few simple steps they are relatively easy to master.

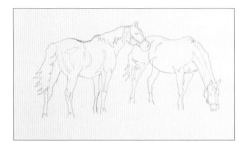

1. Make a pencil outline, and indicate where you wish the highlights on the bodies to go.

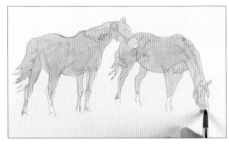

2. Block the horses in with a pale wash of raw umber and burnt sienna using a no. 8 round brush. Allow them to dry.

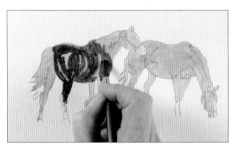

3. Use a stronger version of the same mix to put in the main colour, taking care to avoid the highlights that you marked on the initial drawing.

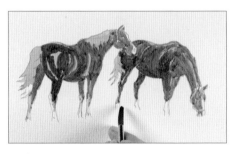

4. Continue putting on the main colour, following the contours of the horses' bodies with your brushstrokes.

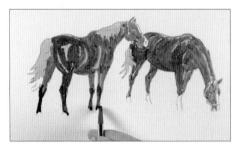

5. Now use a little raw umber on its own to put in the darker brown on the lower parts of the horses' legs. Blend the colour in with a damp brush.

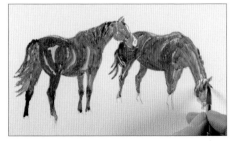

6. Use the same colour to add dark patches to the manes and tails.

68

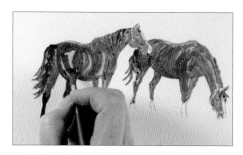

7. Soften the edges of the highlights with a damp brush.

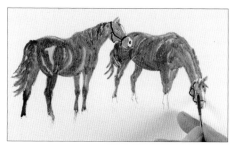

8. Change to a rigger brush and put in the harnesses, eyes and nostrils using ultramarine blue and burnt sienna.

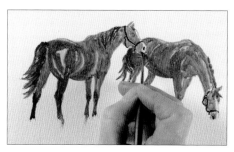

9. Add a touch of black to the manes and tails, then put a little pale blue into the white socks of the horse on the right, and on to the face of the horse on the left.

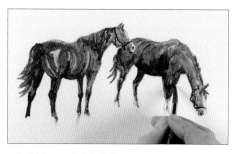

10. Make a slightly lighter mix of ultramarine blue and burnt sienna and put in the final shadows.

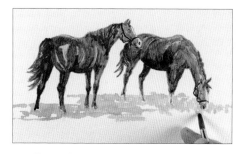

11. Put in the grass, with a little shadow underneath the horses.

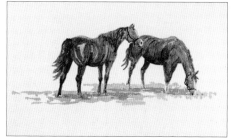

The finished painting.

CREATING TEXTURE

Texture in the landscape gives depth to your painting and makes it come to life.

How to create a textured surface

The technique below is suitable for creating stone walls, flint buildings, in fact anything that requires a textured background.

1. Begin with an undercolour of raw umber and yellow ochre mixed, then stipple on a darker, fairly dry mix using a split no. 8 round brush. Here I have used raw umber.

2. Stipple on a little cadmium blue in exactly the same way.

How to paint rocks and stones

The texture of rocks and stones is easy to achieve using the edge of a credit card. Here I am using only three colours – yellow ochre for the lights, raw umber for the mid tone and a mix of ultramarine blue and burnt sienna for the darks.

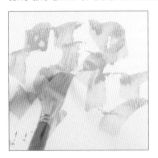

1. Using a 2cm (¾in) flat brush, lay on the colours in a random pattern. Begin with the lightest colours first.

2. Introduce the mid tones, followed by the darks. Leave some of the background colour showing through here and there.

3. While the paint is still wet, scrape out the rocks using the edge of a credit card. Leave a little gap between each 'scrape' – here the wet paint will gather and create shadow.

How to create a cobbled street

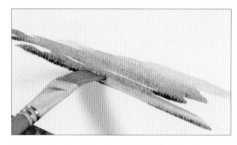
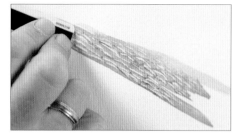

1. Use the tip of a 2cm (¾in) flat brush to lay on the undercolour.

2. While the paint is still wet, use the corner of a credit card to scrape out the cobbles. Make the cobbles smaller as they recede into the distance.

How to paint a dry stone wall

1. First, sketch out the dry stone wall using the same colours as you used for the rocks.

2. Using just the corner of the card, scrape out the stones. Press down harder for a slightly broader stroke, and avoid making the stones too regular.

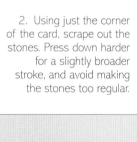

3. For the coping stones on the top of the wall, use the same strokes but place them diagonally.

MAN-MADE STRUCTURES

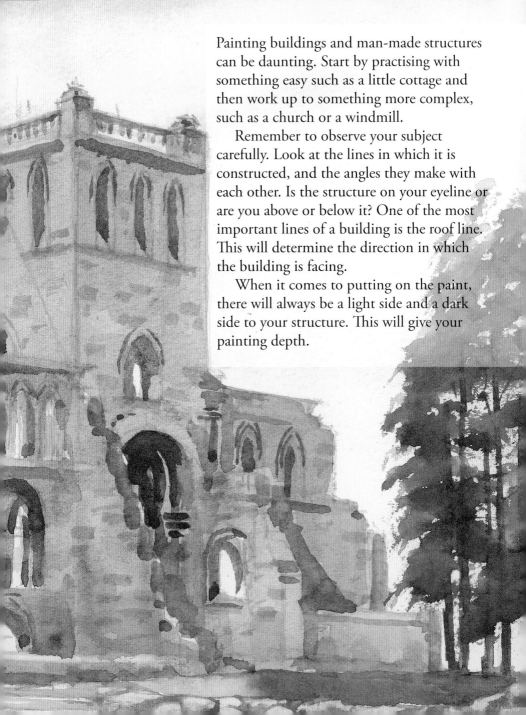

Painting buildings and man-made structures can be daunting. Start by practising with something easy such as a little cottage and then work up to something more complex, such as a church or a windmill.

Remember to observe your subject carefully. Look at the lines in which it is constructed, and the angles they make with each other. Is the structure on your eyeline or are you above or below it? One of the most important lines of a building is the roof line. This will determine the direction in which the building is facing.

When it comes to putting on the paint, there will always be a light side and a dark side to your structure. This will give your painting depth.

How to paint a cottage in the landscape

Here I will demonstrate some useful techniques for painting windows, doors, roofs and dry-stone walls, and for giving your paintings a sense of depth and perspective.

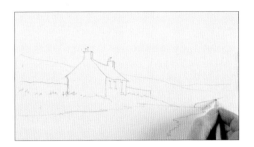

1. Begin with a simple outline of the cottage and the surrounding landscape. The lack of straight lines emphasizes the age of the cottage – notice the sagging roof. Also note that the apex of the roof goes down slightly. This helps it recede into the distance. Similarly, the path is a lot narrower in the background than in the foreground.

2. Starting with the sky, including the top of the cottage, lay on a wash of water, followed by yellow ochre, ultramarine blue and a touch of burnt sienna. Suck out some clouds (see page 34). Repeat the process for the ground, adding Hooker's green and burnt sienna for the grass. Leave to dry, then paint in the distant hills. Leave to dry. You are now ready to paint the cottage.

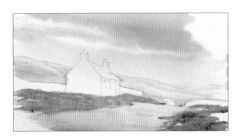

3. Begin with a simple wash of raw umber, using a no. 8 round brush.

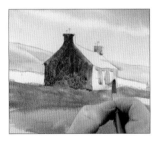

4. For the far chimney stack and the front of the cottage, use a lighter version of the same colour by simply adding more water to the brush. Avoid painting the windows and door.

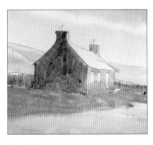

5. If there is a dry-stone wall next to the cottage, it will probably be built from the same rock as the cottage, so paint it in the same colour.

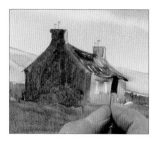

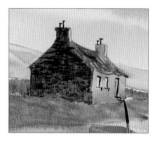

6. For the roof of the cottage use a mix of ultramarine blue and burnt sienna. Leave a few stripes of the white paper showing through.

7. To give the impression of stonework on the side of the house, use raw umber with a touch of ultramarine blue and stipple on the colour with the tip of a 2cm (¾in) flat brush.

8. Use a rigger brush to put in the windows – just a simple line for the top, far side and windowsill. Use a dark mix of ultramarine blue and burnt sienna. Put in the door, the steps and the chimney pots in the same, simple style.

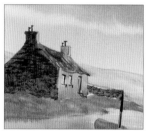

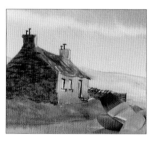

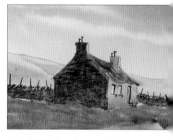

9. Add detail to the now dry wall using the same brush and the same dark mix. To give the impression of stonework, simply 'wiggle' the brush over the surface of the paper.

10. Still with the same colour but using the tip of a 2cm (¾in) flat brush, place a few diagonal lines on top of the wall to indicate the coping stones.

11. With the rigger, add some tall posts along the length of the wall. Ensure they get shorter as they recede into the distance. This will emphasize the perspective.

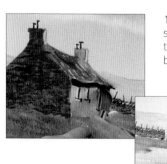

12. Return to the no. 8 round and lay a deep, strong shadow under the eves of the roof. Stroke the colour downwards with the tip of a clean, damp brush to soften it.

13. Use a strong mix of Hooker's green and burnt sienna and the 2cm (¾in) flat brush to put in the grasses in the foreground. Tap on the colour with the side of the brush, then flick up the taller grasses with the corner.

74

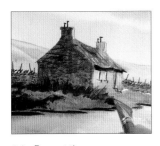

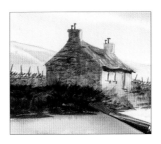

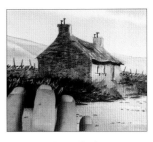

14. Repeat the same technique along the side of the house. This will 'seat' the cottage in the landscape.

15. Using a bluer version of the same mix, put in some darker grasses.

16. To help unify the painting, put touches of the same colour into the path, then scrape out some colour from the grass area using your fingernails for the taller, lighter grasses.

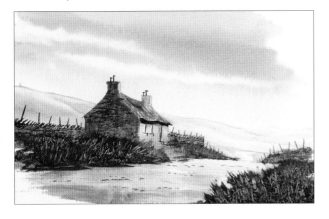

17. Complete the painting by dry brushing over the surface of the path with the 2cm (¾in) flat brush.

How to turn a cottage into a row of terraced houses

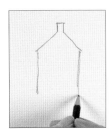

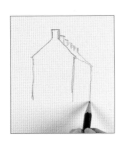

1. Draw the end of the nearest cottage in the same way as before (see page 73, step 1).

2. Add the front of the building, this time extending it and making it longer. Put more chimneys, and parts of chimneys, on the roof.

3. Draw more windows and doors, making them smaller than those on the cottage.

4. Add some detail – TV aerials, telephone lines and so on.

How to paint a gate

An open gate can draw the viewer into a painting, and invite them to follow a path or cross a field to discover what lies beyond. A closed gate, on the other hand, will create a barrier. So open the gate, and invite the viewer in.

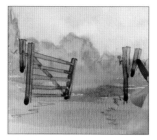

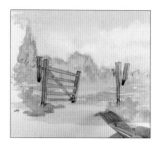

1. Lay a very simple background wash, allow to dry, then draw the outline of a five-bar gate and two fence posts.

2. Using a no. 8 round brush, paint the wood with a mix of ultramarine blue and raw umber. Make one side of each post darker to indicate the direction of light; strengthen the base.

3. When dry, change to a 2cm (¾in) flat brush and start to put in the grasses and shrubs using some yellow ochre.

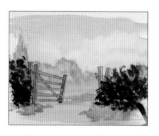

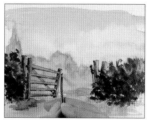

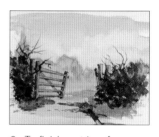

4. Change back to the no. 8 round and stipple on some more yellow, followed by green (Hooker's green and burnt sienna), followed by a touch of ultramarine blue for the very darkest shadows.

5. Strengthen the shadows on the gate using a mix of ultramarine blue, alizarin crimson and a touch of burnt sienna. Add a little more burnt sienna to the mix and use a rigger to add detailing to the gate.

6. To finish, put in a few twigs and branches using a mix of ultramarine blue and raw umber, then add the grass using Hooker's green and yellow ochre, and finally lay a little shadow across the path.

How to paint castles and ancient ruins

Ancient ruins and very old churches can make wonderful paintings, and you don't need any straight lines! Produce the effect of age and weathering by including plenty of uneven lines and bumpy surfaces. Texture is important when giving character to something that is very old and corroded (see page 70). Avoid flat colours; apply the paint unevenly using a range of colours and tones to achieve a mottled effect.

This painting is of an old church. The viewer is drawn through the doorway into the lit interior, which is painted using bright, clean colours to contrast with the more subdued tones of the exterior. Look carefully, and there is not a straight line in sight, so for this kind of subject put your rulers away.

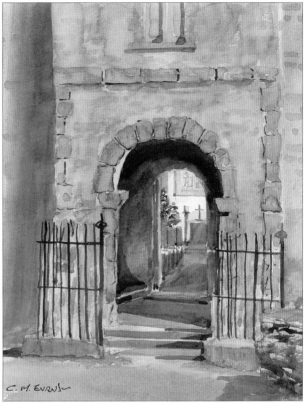

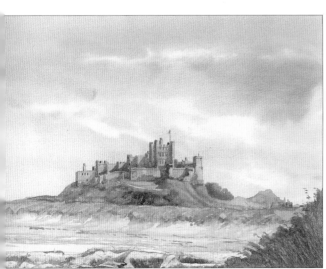

Castles can be very strong, imposing buildings in a landscape, and for this reason need to be made the main subject of the painting.

The painting on the left is of Bamburgh Castle. It stands in a very prominent position in an otherwise fairly flat but nonetheless dramatic coastal landscape. Notice how the castle is brought to life with the use of strong, diagonal shadows.

Painting a row of black-and-white houses

This row of houses is actually the Swan Hotel in Lavenham, Suffolk built in about 1460. Notice the uneven roof lines, and the way the buildings are leaning slightly here and there. But it is the shadows that really create the mood. Here I have used a lot of blue on the white parts of the buildings, which means that where I do leave white paper showing on the lightest parts, it shows nice and bright. The black of the beams is created using a good, strong mix of ultramarine blue and burnt sienna to contrast with and emphasize the white. Remember that there is no finer white than the white of the paper, so there is no need to use white paint.

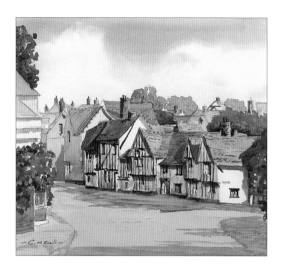

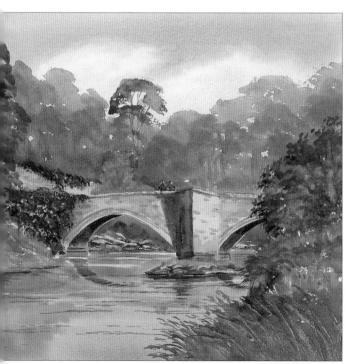

How to paint a rustic bridge

When painting bridges with more that one arch, you need to make a fairly accurate drawing; remember that in most cases the arches need to be the same size and shape. Once the drawing is done the rest is relatively easy. Fill in the shape with paint and create texture by putting in a few individual stones here and there. Place strong shadows where needed to create form. Notice that the dark undersides of the arches are reflected in the river below. Finally, the addition of figures on top of the bridge adds a sense of scale.

How to paint boats

Boats can be quite a complicated shape, but look carefully at this one. It is viewed more or less side on, and the only difficult aspect of the drawing is getting the bow sharp and the stern more curved – it really is that simple. The strong colours I have used to paint this little boat help bring it forwards in the painting, making it the main subject. I have placed it against a simple background consisting of a very pale blue wash.

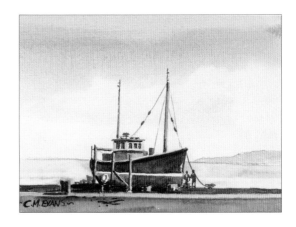

How to paint a windmill

The main subject of this painting is a little windmill in Norfolk, on the River Thurne. Once the drawing was done and before putting on any paint, I used masking fluid and a small brush to paint in the sails and the top of the windmill. Once the masking fluid had dried, I painted the trees with plenty of blue mixed into the green, which helped to push the windmill forwards. When the painting was dry, I removed the masking fluid. I then emphasized some of the white areas by putting a mixture of blue and burnt sienna along the darker sides and in the shadows.

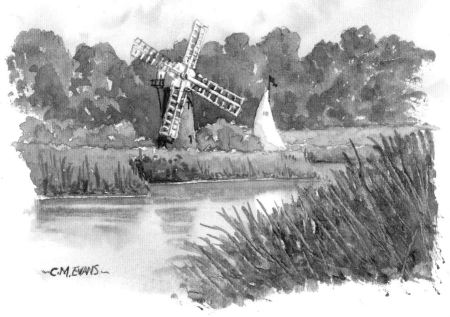

WATER

Water can be a very daunting subject to paint in all of its forms, but don't be too afraid of it. In most cases it is simply the same colour as the sky, sometimes with whatever it is surrounded by reflected into it. Treat it as just another big wash, and once it has dried add any detail that you wish.

In this section I have explained how to paint many different types of water in the landscape, including the sea, rivers and lakes, and none of them are very difficult to master.

The painting opposite is of Warkworth Castle in Northumberland. Notice how the painting is divided in half horizontally, with the land above and the water below. If you want to create an imposing landscape with water, give as much importance to the water as to what is above it.

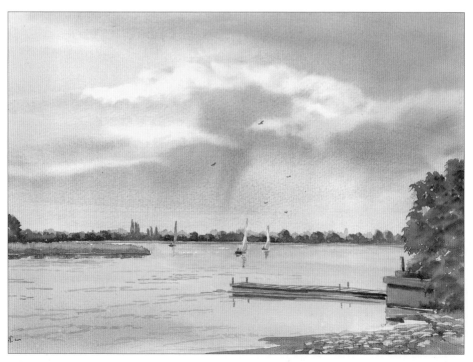

Cloudy day on Hickling Broad.

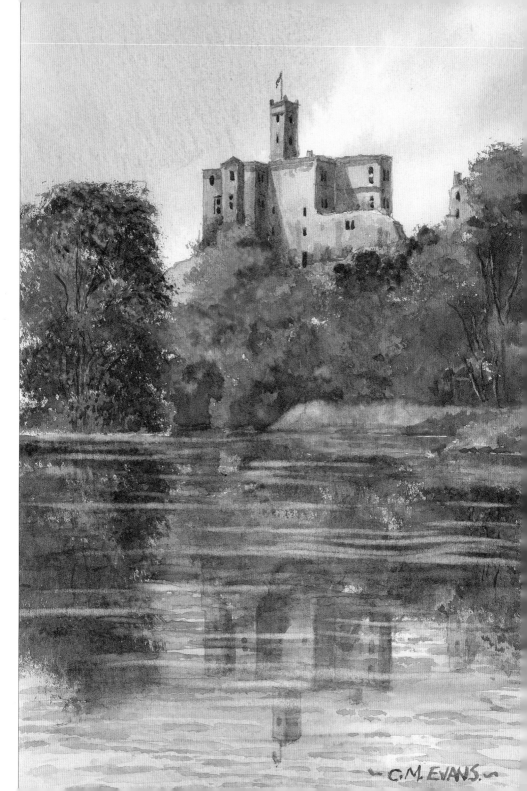

G.M. EVANS.

How to paint ripples

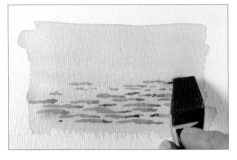

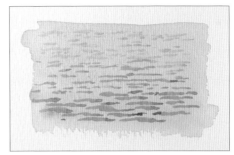

1. Begin with a flat wash of light blue (here I have used cobalt blue) and allow it to dry. Then, with the tip of a 2cm (¾in) flat brush, put in small, horizontal brushtrokes using the same colour mixed with a touch of burnt sienna.

2. As these very simple strokes recede into the distance, make them shorter, and use a slightly weaker mix by adding more water.

Creating the illusion of flowing water – rivers and streams

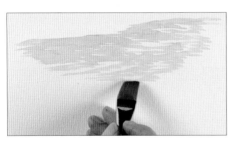

1. As you lay on a fairly weak undercolour (here, I have used cobalt blue), leave a few white patches here and there. Allow this layer to dry.

2. Make a darker mix of cobalt blue, burnt sienna and a tiny touch of Hooker's green. With a 2cm (¾in) flat brush, apply the colour using the tip of the brush, leaving some of the underpainting and the white paper showing through. Make sure the darker colour gets weaker as it recedes into the distance (see step 2 above).

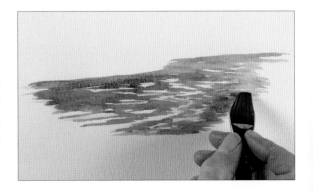

How to create reflections

When putting reflections into any kind of water, use darker, more watery versions of the mixes you used to paint the objects themselves. Paint the reflections in first and let them dry thoroughly before putting the water colour over the top. Use light, quick brushstrokes for the water to avoid disturbing the reflections underneath.

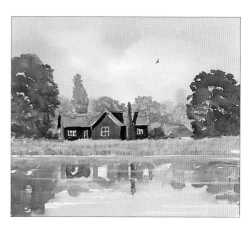

Cottage on Hickling Broad.

How to paint a waterfall

A few rocks and a waterfall is a very simple, but effective, subject to paint.

1. Start by putting in the rocks on either side of the waterfall. Use a 2cm (¾in) flat brush and paint them in using yellow ochre followed by raw umber.

2. Next add ultramarine blue and burnt sienna mixed to a black.

3. Merge and soften the colours a little using a clean, damp brush.

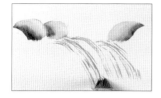

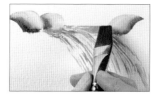

4. Make a fairly dry mix of ultramarine blue and burnt sienna, and use the same brush, this time split, to put in some very simple downwards strokes.

5. With a slightly darker mix, use the corner of the brush to put in the river at the top of the waterfall.

6. Add some grasses using Hooker's green and burnt sienna by dabbing on the paint then flicking up with the brush.

How to depict moonlight falling on water

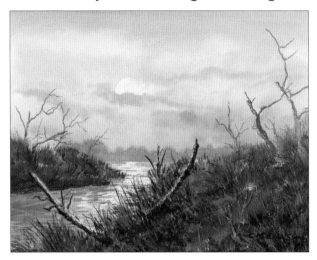

After painting this moonlit sky, I put a very weak wash of cobalt blue with a little burnt sienna on the water. At this stage I added a few touches of yellow ochre here and there, leaving plenty of white paper showing through more or less directly under the moon. Once this had dried I went over the water again with a stronger mix of the same colour, this time leaving patches of the underlying wash showing through.

How to depict sunlight falling on water

This is very much the same technique as was used for the moonlight painting above, but as it is a daylight scene I have painted the water with the same blue as the sky and made it lighter. The areas that were left white during the first wash have been painted using the same yellow as I used in the sky, though with some small patches of white still visible. Once dry, I have put on a stronger version of the water wash, as before, but left some of the yellow showing through here and there.

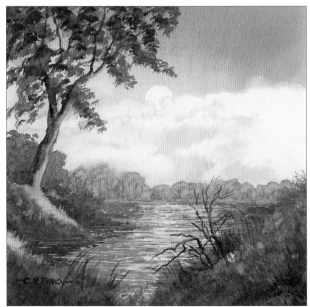

84

How to paint the sea

When painting the sea I always use more or less the same colour mixes as I used in the sky. I vary the depth of the sea by altering the strength of the mix – for deeper water I keep the paint strong, and for shallower water I put a lot more water into the mix.

When the waves are fairly weak and the surface of the sea is just a gentle ripple, I use small, horizontal brushstrokes and leave a few wavy white lines here and there, but without making them too big. When the sea is heavier or more stormy, I make the white lines more pronounced, sometimes drawing in the outlines of the white areas so that I know where not to paint. This saves the need for masking fluid.

Whether the sea is flat and calm or rough and stormy, the waves need to be defined by a shadow placed underneath to indicate the curl of the wave.

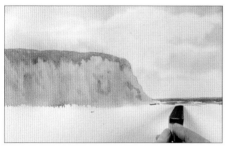

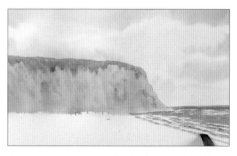

1. Start at the horizon, and use a mix of ultramarine blue, Hooker's green and burnt sienna. Touch the colour on in horizontal strokes using the tip of a 2cm (¾in) flat brush, leaving some of the paper showing through here and there.

2. As you come towards the foreground, alter the angle of the brushstrokes, if necessary, to define the shoreline, and leave stronger, wavy lines of white. Go along the edge of some of the white lines using a slightly darker version of the blue to give the illusion of breaking waves.

Alone on the Beach. Druridge Bay, Northumberland.

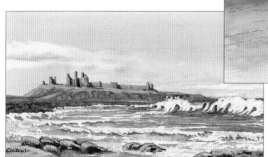

Dunstanborough Castle, Northumberland.

MOUNTAINS AND CLIFFS

In this section you can have an amazing amount of fun with a credit card and a lot of water. Unusually, the credit card won't cost you any money, and it is amazing how effective it can be.

The painting on this page is of Cheddar Gorge. Notice how the dramatic use of shadows has created a sense of the size and splendour of this fantastic natural landscape.

C.M. EVANS

How to paint a distant mountain range

Ranges of mountains and hills have their own individual shape, so it is important to observe your subject carefully. Here the range of mountains I have painted is purely a product of my imagination, but the method for painting them will be the same.

1. Once the sky is dry, there is no need to draw in the mountains; go straight in with a 2cm (¾in) flat brush and yellow ochre paint. Think about where the light is coming from – it is very important to capture some light and highlights at this stage.

2. Painting quickly, add a little raw umber to define the shaded areas.

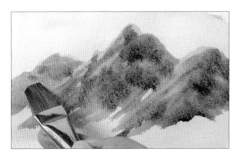

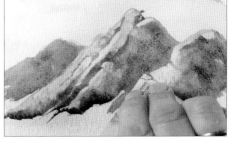

3. Darken the shadows further with a little ultramarine blue and a touch of burnt sienna.

4. Using a credit card, scrape out the shapes of the rocks (see page 70).

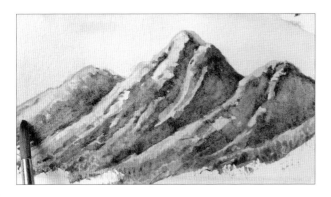

5. Put a little dark shadow colour back in using a mix of ultramarine blue, alizarin crimson and burnt sienna applied with a no. 8 round brush. Think about the shapes of the shaded areas and remember to emphasize the shadows in the dips and crevices on the light sides of the mountains, as well as the shadows on the shaded sides.

How to paint a snow-covered mountain range

No drawing is necessary in this kind of painting. The mountains are actually defined by the shadows, which are painted in first, then colour is simply scraped away with a credit card to reveal the light areas. When painting snow, always use a little blue in the shadows.

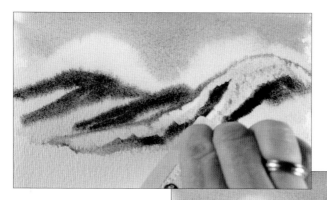

1. Paint in the mountains using a very dark blue mix of ultramarine blue and burnt sienna. Make a darker mix for the shadows by adding more burnt sienna. Scrape out the texture with a credit card, as before, and soften the edges with a damp brush.

2. Continue scraping out and softening the colour until you are happy with the result.

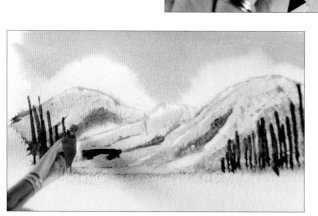

3. Make the mountains recede by placing some trees in the mid-ground. Use a mix of Hooker's green and burnt sienna and paint each tree trunk using the tip of a 2cm (¾in) flat brush held vertically, as shown.

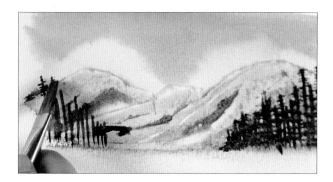

4. With one corner of the tip of the brush, put in the short horizontal branches. Widen the branches towards the bottom of the tree by laying on more of the brush.

5. Finally, put in the foreground using a touch of blue mixed with plenty of water, applied with horizontal strokes.

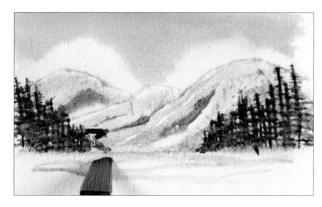

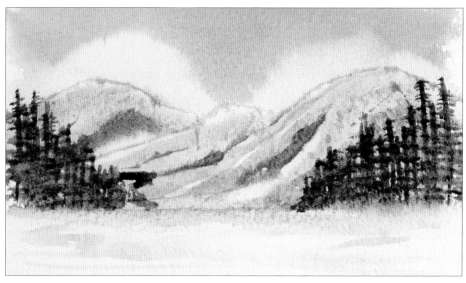

The finished painting.

How to paint a headland

Painting a large headland is not as difficult as you might think. Just use very wet paint and drop all the colours in together using the wet-in-wet technique. Let the colours spread naturally on the paper, then add definition with the use of shadows.

1. Begin with a simple sky wash, allow it to dry and draw in the outline of the headland. Wet the headland area using a 2cm (¾in) flat brush and while it is still wet drop in some yellow ochre, avoiding the grass area on the top.

2. Working quickly with the same brush, drop in some raw umber and let it spread and blend with the yellow.

3. Next, add in a little light red, again working quickly so that the colours mix and blend on the paper.

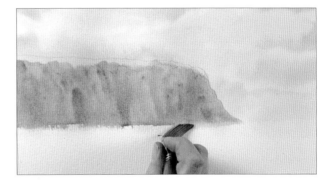

4. Mop up the surplus water along the bottom of the cliff using the tip of the brush.

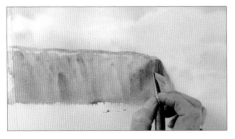

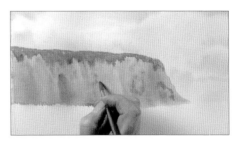

5. While the paint is drying, put in a strip of yellow ochre on the top of the headland, where the grass will be.

6. Change to a no. 8 round brush and add a little Hooker's green mixed with yellow ochre. Drag this colour down into the cliff face, creating light green patches here and there.

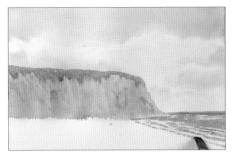

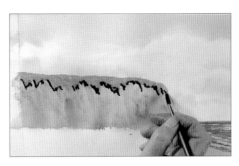

7. While the paint is drying, start to put in the sea using a mix of ultramarine blue, Hooker's green and burnt sienna and the flat brush (see page 85).

8. Returning to the headland, start to put in the shadows just underneath the grass area using the no. 8 round and a mix of ultramarine blue, alizarin crimson and burnt sienna.

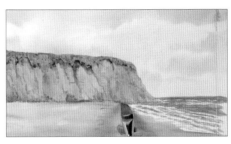

9. With a clean, damp brush, drag the shadows down and soften them slightly. Move the pre-applied shadow colour around to form the crevices and cracks. Put some shadow colour into the grassy area on the top of the cliff.

10. Use yellow ochre to put in the beach. Use the flat brush. As it gets closer to the sea and becomes wetter, add a little raw umber to the mix to darken it.

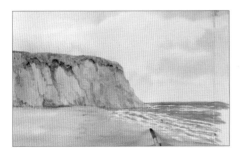

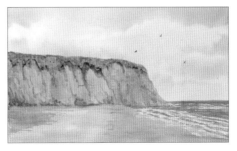

11. Add a little ultramarine blue mixed with plenty of water to define the edge where the sea meets the beach.

12. Finally, stroke on a touch of shadow on the left-hand side of the beach and put some birds in the sky to add a sense of scale – just three 'ticks', using a mix of ultramarine blue and burnt sienna applied with a rigger.

MOOD AND ATMOSPHERE

An attractive painting is one which draws the viewer to it, and the best way of doing this is to add interest by introducing a sense of mood and atmosphere. In this section I will draw on all the techniques described elsewhere in the book to show you how.

Early morning mist

I painted this picture of early morning mist just as I would paint any other landscape. I have kept the colours slightly stronger than normal here and there, then once the picture had completely dried I simply sucked out the paint along the bottom of the woodland and into the hedgerow using a clean, damp 2cm (¾in) wash brush.

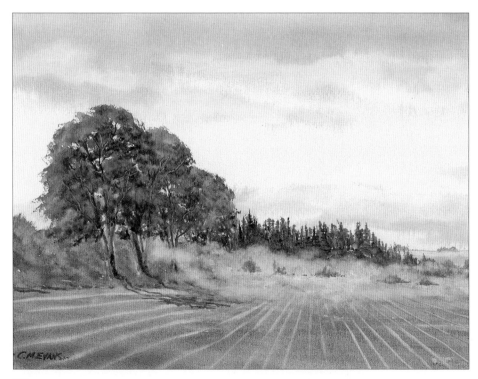

Snow scene

This winter scene evokes memories of evening walks through the snow. In this kind of painting, with a strong sunset-coloured sky, it is important to capture the colours of the sky in the snow. Use blues and greys to depict the strong shadows, and avoid painting the trees in too much detail – those in the distance are simply weak silhouettes, due to the failing light.

A sunny beach scene

When painting a beach scene, avoid a boring, flat beach by adding tidemarks in the form of wavy lines of light red and raw umber using a rigger brush, and add other patches of colour here and there. The light is captured on the beach as well as on the front of the white building on the right. For all the shadows I have added a touch of blue. The addition of people on the beach, and birds flying overhead, reinforce the suggestion of a sunny day, as well as giving scale and depth to the scene.

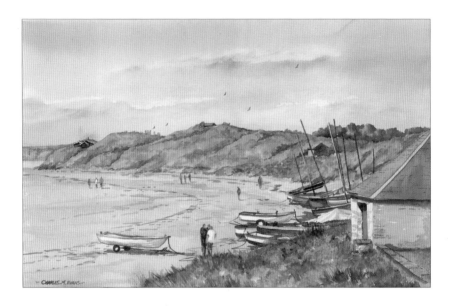

Bleak moorland

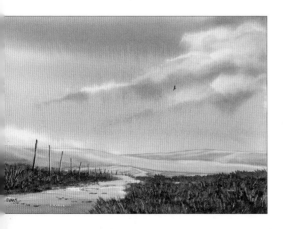

In a painting like this, the sky determines the atmosphere of the whole painting. The power of the elements and the bleakness of the landscape are enhanced by the huge, strong, overcast sky, and I have created extra depth by using pale yellows and blues in the distant hills and adding a strong foreground. The vertical posts and the horizontal path draw the viewer deep into the painting.

When I am painting a sky like this, I use plenty of water and have my board at a steep angle. This allows the paint to run and create that lovely impression of rain from the heavy clouds.

How to paint a night scene

Avoid making the sky black in a night scene; instead paint the
sky a very deep, strong blue. The white orb of the moon creates
interest by casting light on to the nearby clouds and the ground.
Notice the backlighting at the bottom of the sky, suggesting
that dawn is approaching. This also serves to highlight the
silhouettes of the trees on the horizon, and it is important to
keep these very dark.

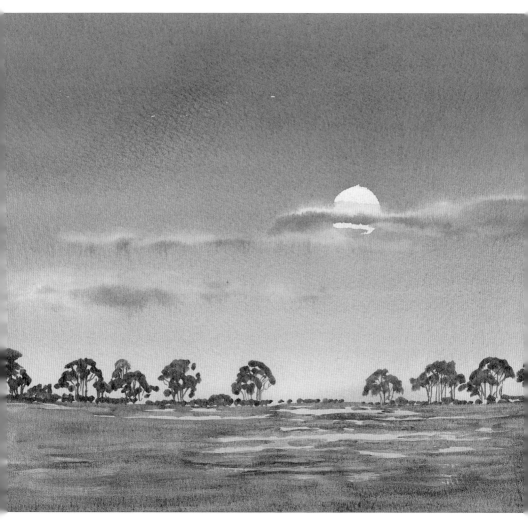

INDEX